When Robert M

Written with Illustrations by Alice Lenkiewicz
Copyright © 2019 by Alice Lenkiewicz

First printing, 2019.
ISBN 978-1-64606-195-2

"All proceeds of this book are in Aid of Shelter"

Acknowledgements

I would like to thank Alex Donoghue, Lemon, Derek Winkworth,
Lee Benson, John Pollex, Ted Whitehead and Don Brown, Tarun
Bedi, Chris Kelly, Mark Price and The Lenkiewicz Foundation for
their contribution of memories and photographs.
I would also like to thank my beautiful mother, 'Mouse' for her
support and contribution of memories, letters and photographs.

*To dear
Angela,
Loves to
meet you.
alui
X*

2

Introduction

Time has moved on and life has changed. Throughout all these years I have experienced many emotions, have read the opinions and thoughts of others and have read the news articles. It is always tempting to not write about these memories or thoughts but there comes a time when you just need to express yourself.
I first put pen to paper with this memoir in 2009 and then suddenly I just left it alone and unfinished for many years. I realised I found it quite unsettling to face writing it at times. Each time I captured a memory, it reminded me that my father was no longer here. I think things were still too raw. I left this memoir alone in disarray for many years and then recently I decided I was ready and it was now time to complete it and put it out there for others to read.

Re-visiting it was a positive experience, although quite strange, as if I was being transported back in time. Each time I wrote down my memories, I imagined myself walking up the stairs of my father's studio, into that big wonderful space where he created his art. He would be standing there with his tall majestic presence. I would sit down on one of his brightly coloured painted chairs and he would continue painting me. I write also of my memories of my lovely mother, Mouse and how I remember her in my youth. She was and is such a free spirit, a beautiful woman and great company. She has always been there for me.

I loved Robert dearly. We had so many fun and interesting conversations and times together. We had a wonderful friendship. My mother and I had shared some valuable years with my father. This memoir is based on my own experiences and that of my mother's and significant memories from some of my father's good

friends. I wrote a great deal in diaries in my youth and that has always helped me define and clarify the journey in my life. This is my way of celebrating Mouse and Robert's relationship, looking at my own relationship with Robert and the support Robert and Mouse offered to the homeless and my own reflections of two very unique people. I would like to thank the friends of Robert and my own mother for their contribution of memories and photographs.

Chapter One

Strange Tales

When I was a little girl, I remember browsing through one of my father's books. There in front of me was the image, an engraving in black ink. The picture has haunted me for years. It portrayed a curvaceous woman with hair so long, down to her knees. She combs her hair while peering at herself in a hand-mirror, while in the background; the devil is grinning from a doorway without her being aware. I asked Robert what it meant and he just smiled mischievously. But for me, this image was a symbol of vanity and sexuality. The devil was her voyeur. 'Vanity, vanity, all is vanity," as my father used to say. But then as I grew older, I disliked the image even more so I drew a different picture of the woman looking in the mirror, only this time her own reflection was the devil while her husband looked innocently in on her. I couldn't resist it. I'm sure Robert would understand. Maybe that was my first glimpse into exploring a woman's sense of self-empowerment.

My father used to collect clear glass paperweights with all the tiny detailed millefiori, embedded inside the glass. Holding them in my hands I would feel their cool smoothness and peer into the centre until a kaleidoscope pattern of colours cascaded together, injecting rays of light from the window and distorting the objects in the room. I loved those paperweights. There was also the toy jester with the innocent look, the gold bells hanging from its hat. And of course, the stork, that amazing stork that Robert made out of light blue papers and papier-mâché. It was huge and stood next to the wall, its large golf ball eyes gazing humorously out into the world.

Robert was a big follower of eccentric, magical and fun things like Disney characters as well as strange fairytales and nursery rhymes that he used to read me. He was also a great fan of the tarot. I

remember him showing me a pack of tarot cards in his library. These were the AG Muller design from Switzerland. I was fascinated by them. We browsed at all the beautiful images and discussed the symbolism; the first emblem is *The Fool*, the most controversial image in the Major Arcana of the tarot cards. Robert even opened a shop called The Fool once. The Fool is innocent, on the beginning of his journey. He does not know what will befall him. All he cares about is the excitement and the unknown adventure that is about to begin. Robert, I feel was akin to this sentiment and approach to life.

This was Robert's phase of the Fool. He wore bright coloured scarves; he painted objects in fluorescent pinks, oranges and yellows. I remember he once painted a radio with bright 'folk art' style colours. His life at this time was a jingle of magic and foolery, his own invention of 'Penoob' faces and silliness. Innocence was the mood. The journey was the adventure the unknown was exciting. Answers, facts, tradition and seriousness were unimportant. It was a time of fun and excitement. The importance was in the seeking not the finding.

This was the era of optimism and irrationality. There were those familiar elements of Robert that epitomised the flower child of the sixties. He was enjoying the carnival of life. He was 'The Laughing Cavalier' of the Barbican in Plymouth, the man who epitomised anti-convention, the man with the wild mane of hair, the red scarf, the cavalier boots, (actually old firemen boots) the black velvet smock and oil paint covering his hands and clothes. He didn't care, he was happy. I can still picture him now, finishing off a painting, walking out of the door of his studio and us both sitting in Jo Prete's Café on the Barbican in Plymouth when we were on our regular coffee meetings. I can see him so clearly.

The first book Robert gave to me was *Der Struwwelpeter*, written by Heinrich Hoffmann. Robert was fascinated by these esoteric rhymes,

fairy tales and fables. I remember him sitting me on his knee when I was a child and reading me these haunting rhymes. I listened carefully to all these Victorian tales and became fascinated by magicians and spirits, the horror and grotesque, the haunting spirituality of fairy-tales were an important part of the fictionalised world of books that I absorbed as a child.

As a child, Robert was like a magician and a friendly ogre. He was also like a proud King, refined and very much a gentleman. He was a combination of many things. He was fun and eccentric but also on a serious level, he was fascinated by the mysterious and esoteric and many other magicians including John Dee. In later years I bound an old edition by Agrippa and Dee for Robert. My bookbinding years with Robert were certainly memorable. Robert also read me stories by *Dr Seuss* and he adored the story *Cat in the Hat!*
But one of the main stories Robert read me, that terrified but also fascinated me as a child, was the story of *Bluebeard*. If you read this story, it is actually quite horrifying. It is written by Charles Perrault and is an original French folk tale. It could also be construed as a horror story. It is about a man who tortures and kills all his wives. His last wife survives and finally escaped after discovering his secret chamber of horrors in his castle. Her brothers save her and kill Bluebeard. It was one of those terrifying fairy-tales that held much symbolism. Looking back, this is actually a story about misogyny and also women's empowerment. This book probably taught me a great deal in terms of domestic violence at a very early age. For Robert, Bluebeard was one of those strange and fascinating fairy-tale villains.

The first music that Robert played to me was the album *Peter and the Wolfe* with music by Prokofiev. This beautiful composition with the story and musical instruments engaged me for hours and it was spoken by a man with a beautiful voice. It began like this…

''Each character in the tale is going to be represented by a different instrument of the orchestra. For instance, the bird will be played by the flute. (Like this) Here's the duck, played by the oboe, the cat by the clarinet, the bassoon will represent grandfather, the wolf by the French horns. And Peter by the strings...Are you sitting comfortably? Then I shall begin...''

I used to listen to this record many times, imagining Peter and the most tragic part of the story when the wolf swallows the duck whole. That image used to horrify me.

The first song I ever really loved was 'Rocky Racoon' by The Beatles. My mother's friend would play it on the record player for me. I have memories of being at Robert's house in Priory road, listening to this song as a young girl. I was collecting small pieces of broken coloured glass from the pavement and gluing them to cardboard to make stained glass images. For some reason I will never forget that cardboard. It was just a brown square, like off the back of a TV or something industrial and it was covered in blobs of glue. I remember being fascinated with placing the pieces of glass onto it. I suppose it was my first ever experience of creating a mosaic and combining it with light, something that had been taught to me for the first time; it is strange how we remember these details. I am sure the song; 'Rocky Raccoon' had a lasting effect on me. For many years I had this fascination with cowboys. I always cherished the music by The Beatles and Bob Dylan. As a young girl, growing up in Plymouth, the music I loved most of all was from the sixties. I listened to these songs in my bedroom for many years. When the famous film star, John Wayne died, I was still at school and I remember being quite devastated. I loved John Wayne. Teenage girls tend to have a hero. My heroes were John Wayne, Clarke Gable, and Elvis and of course, Robert, my wonderful artist father was also my hero.

In some ways I knew him but in other ways I haven't a clue. To me he was an enigmatic man and he could be very funny! I used to laugh a great deal with Robert. There were times when I visited him at his studio and he would be standing there in his light brown duffel coat and suddenly he would do a dance all over the studio, bounding and springing from one foot to the other around the room with his arms stretched in the air. It used to really make me laugh.

There was always excitement in the air when meeting Robert. He was full of life and full of inspiration which was highly infectious. He was a joy to be with. And sometimes he would go very quiet and serious to the point where you could almost feel uncomfortable. Robert had this amazing ability to make people feel extremely important. He made the homeless famous in his paintings, allowed us to see them as intriguing people that many would normally have never given a second thought. He made people feel important in many ways. I remember visiting him from school and him placing this giant heavy book in my arms to borrow. He didn't give me a reason why he even gave it to me. I was about fourteen and the last thing on my mind was reading huge crumbling, antiquarian books. I was probably thinking about some boy I had met or going to the disco on Saturday night and what I would wear. But there I was walking through Plymouth city centre in my school uniform carrying giant leather bound, rare book. As I went shopping for clothes in Miss Selfridge, I would place it on the seat as I tried on clothes in the changing room. It was probably of huge value. In my own way I did treasure having it in my possession.

When I returned the book, Robert would look at it for a while as if it had been missing and he was thankful to find it. I remember him carefully placing it back in his bookshelf with a frown and a serious look upon his face. Then he would slowly turn to me and stare at me for a few moments in serious contemplation. Looking back, remembering these moments, make me smile.

Chapter Two

When Robert Met Mouse

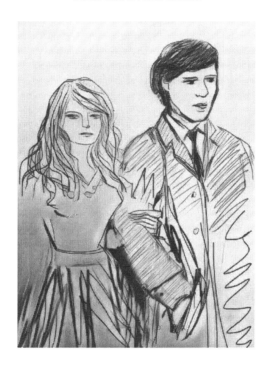

Mouse met Robert at St Martins College of Art in London. You can imagine what a fascinating time this was. Mouse always mentioned the sixties in terms of films, fashion and music such as Mary Quant, The Beatles, The Doors, the film, *West Side Story*, one of Mouse

and Robert's favourite films. It was all happening! And there in amongst all of this was Robert and Mouse with their own dreams.

Mouse had just been accepted by St Martins College of Art in London and Robert happened to be there also. Mouse loved art and she was talented. My earliest memory of her work was a painting on a board of beautiful tones of green apples amongst leaves on a tree. I loved that painting. I remember it in our home for many years. Another painting I grew up with was a painting of Mouse's close friend, Irene by Robert. It was a beautiful portrait of an older woman and was displayed on our wall throughout our childhood and teens. Irene was a close friend of my mother's.

My earliest memories of Roberts's paintings are of old friends such as Lazlo from Hungary, Aury and Pierre, Mouse and Robert's friends. A lot of people passed through our lives in the late sixties and early seventies. I can remember many of their faces quite vividly, even today. I can remember Albert Fisher, also known as 'The Bishop' and his red hair and overcoat. He used to stand smoking a pipe outside Robert's studio. He wore a camel coloured overcoat or sometimes a dark grey coat. He was quite tall.

Albert was a subject of many of Robert's paintings. I remember Terry Goldstone and his black beard and unusual voice. Terry looked after me many times when I was a child. I always loved the painting of him by Robert where Terry is dressed in a white Pierrot costume. It is a beautiful painting. The last time I saw it, it was displayed on the far wall of his newly built library at St Saviours Church on The Barbican and its beautiful luminosity emanated on the far wall beyond the dark aisles of Roberts library shelves full of books.
Mouse went to St Martins School of Art in September 1960. In her interview she submitted a portfolio of 'passionate' work, influenced by Modigliani (all now lost) and the principle liked it. Mouse didn't

quite realise how privileged she was and the class was made up of strong colourful students, Monica Peiser and Rita Palmer as well as Philip Ward-Jackson and Peter Sylvere, Monica Meyer, Aury & Myrna Shoa. Monica Peiser was a good friend and Mouse remembers her wearing strings of home- made necklaces made out of melon seeds, dyed pinks and purples and acorn cups, all beautifully strung together and displayed on tables of velvet for sale. Monica had a striking Polish beauty and Mouse said her sister, Hazel was a film star. There was Philip Ward- Jackson- whose brother Michael apparently wanted to fight Robert in a duel over Mouse. Philip became a well-known figure in the Courtauld Institute. There was Peter Sylvere and his mother, Irene who Mouse loved dearly and Winkle, also known as Derek Winkworth. They all played table tennis in the common room which at the time was full of much cigarette smoke, music and girls dancing to the jukebox.

Mouse remembered Monica Meyer with huge made-up eyes, the heavy black liner and long blonde hair. She danced like an angel. Mouse said there were many beautiful girls in St Martins from the fashion department such as Sarah Rampling, Charlotte Rampling's sister. Lessons were wonderful – a casual atmosphere. Artists were Peter Blake, Frederick Gore, The Temperance Seven, (Jazz group) were also popular.

It was the 1960s and they lived life to the full, they were having fun but they were not yet experiencing what was to come. Mouse said to me, they wouldn't have understood it. At this early point, just before things really started taking off, their lives were far more innocent, similar to *Trilby* by George du Maurier, one of my father's favourite books. Life hadn't yet been disturbed by the later nineteen sixties counterculture. It was still very innocent. It was the last stages of the so called moral nineteen fifties culture, still partially clinging on; the aim and focus for Robert and Mouse at this particular time was mainly art and love, I was told and not sex drugs and rock and roll.

Initially, Mouse was very lonely in London. Although she went back home every weekend to Bourne End with her parents, the weekday evenings with her Grandma, Georgina in London were bitterly lonely. Mouse wasn't used to loneliness. She used to sit in an Italian cafe near the British Museum and just think about her life in general. Her Grandma used to tell her fortune with cards each night in front of the gas fire and she would retire to bed early. They lived in a basement; 7, Bury Place, Russell Chambers, which before her grandfather died was a museum of rare and spectacular books, Japanese suits of armour and shoes studded with rubies and emeralds.

The whole place was fascinating - rare paintings and columns of books. Mouse used to weave her way into the middle of the room where her Grandfather would be cooking beans on toast.
Before Mouse's grandfather passed away, he must have cleared what would have possibly been assets of a million pounds even in those days and he had sold it all down Berwick Market. The buyers may not have believed their luck that day! He was a friend and contemporary of the writer Oscar Wilde and met him in the Cafe Royal every day. He was an extraordinary man. Her grandmother was, according to her father, part Romany gypsy. Her eyes were black and she 'knew' things -had second sight, an amazing woman. I met her once in Liskeard when we were children on one of our frequent visits to Mouse's parent's house in Cornwall. Georgina was our great grandmother. She was a very old lady, sitting at the top of the house in her bed with a shawl wrapped around her shoulders. Georgina was a lady of the Edwardian era. A photo I have of her shows her as a great beauty in her youth. I remember her shawl was green tartan and she used to keep After Eight Mint Chocolate Thins next to the bed. I was always fascinated by her exotic, oriental jewellery box that stood on her dressing table. It was a treasure trove, full of amber and turquoise beads and necklaces, crystal earrings, beautiful clusters of black jet beads and art deco earrings

and bracelets from a bygone era that fascinated us children. I have never forgotten that jewellery box to this day. We used to ask to see it every time we visited!

Mouse told me that one night she went to bed and had a dream. It was her second term at St Martins in January 1962. She dreamed she saw a notice on the wall saying,

"WASHING UP PERSON WANTED. APPLY WITHIN."

Then she forgot about it and the next day she went to college and very strangely, she saw a kitchen lady pinning a notice to the wall - similar to the one she had dreamt about. For some reason she felt she would get the job and looked curiously at the other person washing up. She saw Robert standing there drying the dishes. She had seen him around the college. He was 6' 4" with hair to his shoulders and a long grey coat with a scarf (not done up) and a copy of a Nietzsche paperback sticking out of his trouser pocket. They had philosophies, not pop stars in those days. Good books were their street cred! That was the first time Mouse saw Robert.

Apparently, Robert hung around with a girl called Sue Taylor at college. Mouse, later described her as "sex on legs"- very attractive. Mouse thought she seemed much 'lived' and must have been all of twenty years old. At that time, Robert had a strong aura about him and several of the girls flirted outrageously with him. At lunch time, Mouse would collect all the dirty dishes on a trolley from a full canteen. Quite a few men would ask Mouse out during this time but she was thinking of Robert mainly and she couldn't believe it when one day he walked over to her and said, "Could I paint you tomorrow night?" Mouse said "Yes" and that night she told me she prayed to God that he would love her.

Before all this took place, Mouse had been very in love with a soldier from Sandhurst called Alistair Taylor - Morgan and they

were courting and had just been to see the film Breakfast at Tiffany's together and Mouse has fallen for him and played the song 'Moon River' for months after, on the piano. Suddenly, out of the blue, Robert was in her life and took over on the relationship side and before long; Mouse and Robert were an item. It was a very different world for Mouse. She told me she was so scared and aware of him. She was doing her best to keep expectations set in reality but it was difficult when you were crazy about someone.

Mouse arrived at Robert's studio at Fellow's Road. She looked around curiously at the volume of paintings and murals, many of them burned by his landlady at a later date for unpaid rent (Josie!) It was a dark room, faces gazing from paintings everywhere. Robert told Mouse to sit down and then started to paint her.

The next time, they met at Swiss Cottage and Mouse felt very daring as she saw him sitting on the steps and she suddenly reached out and touched him gently on the shoulder.

They were very aware of one another, the beginnings of falling in love which was fun and exciting. It was months before they kissed as they were so scared of each other and finally, one day in Soho Square Robert asked if he could kiss her and then that was it, they became a couple and were considered the 'odd couple' of St Martins - both good looking but definitely 'odd' and eccentric.

The atmosphere in London at that time was very strong. They lived without money, ate in greasy spoon cafes and went to the cinema once a week. Films watched were *Wuthering Heights, Samson and Delilah* with Victor Mature and *The Sound of Music.* They were happy. They felt, London had embraced them both and they were completely and totally in love with each other and with life! They laughed; they ran, (usually across Primrose Hill!) Mouse could run faster but Robert could run for longer. They would just run for the hell of it and they walked miles along streets, always making for 'somewhere' and as they walked, they would sing songs.

Robert would sing popular songs by Paul Robeson, a singer and actor he admired, songs such as 'Old Man River', 'Lindy Lou', and they both sang to each other that timeless song, 'You may not be an Angel'. That was their favourite. They stopped at many cafes and while they drank coffee, Robert would draw her and then they played chess to exhaustion.

Looking back, they were highly competitive, possessive and terribly jealous of each other (for little reason).

The National Gallery was their second home and they used to meet under the Andrea Del Sarto, *Portrait of Sansovino* and a café called The Book, next door to Foyle's was where they ate and The Loft when they were at home in Hampstead.

Eventually, Mouse left her Grandmother and went with two friends, Rita and Marion to live at Queensway and then Hampstead. It was her one and only 'girlie experience' of living in a flat. However, she remembers feeling incensed with rage at how untidy the place was. Mouse enjoyed living with the girls but in the end, all she really wanted was Robert. Eventually, she and Robert moved in together to a flat in Eton Avenue, London. Mouse loved it there and recalls it as a beautiful and memorable time in their lives. Mouse and Robert's life was dominated by painting, friends, food and chess, all of which were provided in England's lane in Belsize Park. The Loft was a cafe owned by Kim Johnson and Eric the cook. Different friends would arrive and they all sat there late into the evening talking and socialising. Many characters came in there. Mouse remembers a man with long claw-like fingernails and a long, matted mane of hair. Life was mainly centred on home and cafes. They were very poor and there was nothing flash. Meals consisted of potatoes, treacle pudding and custard. They were happy and made the best of what they had.

When they eventually married, they celebrated with friends. Sometimes Mouse went home to Cornwall and up to Yorkshire when her father worked at Fylingdales and correspondence between Mouse and Robert went into hundreds of letters.

They were immature in their constant jealousy although, sometimes when together, no two people could have been happier. Fashion became non-existent. They were young and scruffy. Mouse

remembers wearing a pair of old trousers cut down which belonged to Robert, tied around the waist with a
string. She remembers Robert as not caring about his looks in any way! Sometimes they would visit Ma, Robert's mother (known as Alice Schlossberg) and these visits for Mouse were mildly terrifying. She felt much 'cut off' and she sensed a general overall feeling of dismay from the family in terms of her being non- Jewish. Robert said very little to her about his Jewish background.

I think he was respectful of it and interested but he was never really one for belonging to one religion or a religion at all but there were elements of Judaism, I feel that ran through his life that he never forgot and that inspired him, such as the Jewish Rabbis, the mystical element and the suffering of Jews through the holocaust was of particular interest and sadness to him. The holocaust had a strong impact upon Robert and how he viewed the human condition. He educated me and showed me many books on the Holocaust and the plight of the Jews in the Second World War.

Mouse soon left St Martins and she and Robert both went through a period of just living and painting. Mouse worked in Selfridges and John Lewis and they ate out and Robert paid for their food with drawings and designing menus. One of Robert's passions was poster art. They travelled constantly by tube, often fiddling the fares by jumping the barriers which you could do back then and in the long corridors they would peel off as many film posters that they could from the walls. Robert admired the poster styles of the time - the same way that he enjoyed watching style in people. He introduced Mouse and many of us to 'vision' and would stop in the street teaching her many things about tone and colour. Mouse began to realise the beauty in a piece of corrugated iron and previous concepts of aesthetics were turned upside down.

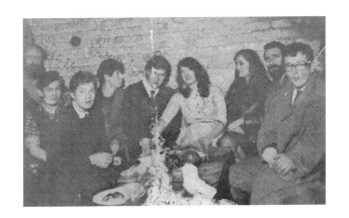

Chapter Three

Romance

Robert and Mouse were only seventeen years old when they first met each other at Art College. Robert painted and sketched Mouse multiple times and she helped him through many difficulties with people suffering from alcoholism and homelessness. Their relationship didn't last forever and eventually they both followed different paths but while it lasted it was quite blissful. Robert wasn't conventional but he was romantic at times. Here are some love letters that Robert wrote to Mouse when he was a young man, when they were about to get married. Mouse gave these letters to me. They are quite fascinating and also very funny and surprising at times! Read them at your leisure.

Letter 1

My darling Mouse
This Friday I shall be sending you £2, 10/- what you do with it is of course up to you, but what I would like you to do, is to come down to London with your things under my pretext, please, you could say I've arranged an office marriage, I think we can get a church marriage whether your resident or not.

I'm going to check out the registrar cos I heard that I can get a 'special license', whether you're resident or not. (I asked Eric as he'd been married 3 times). So I am going to marry my poor little trapped mouse. Incidentally I am now the owner of a beautiful cat, its half Siamese, completely jet black with large eyes the inner ring blue, the outer ring green.

*It belonged to a friend of Michael the painter, who was going to
have it destroyed otherwise.*
I wonder what the landlady will say, it really is very beautiful.
*Please just come down and let's see what happens there's nothing to
be afraid of.*
*You should receive the money on Monday or Tuesday morning; see
if you can come down by the middle or end of next week. I'll look
after you with my life!*

P.S: ERIC SAYS "MAZELTOV",
My Love
Robert X
*P.P.S. I said I was going to Ma yesterday, but I'm going on
Wednesday as I've made an "appointment"*

Letter 2

*My Mouse – aint no use a listening for those clomping footsteps
problems - problems - problems. How are you my Mouse?! Tonight
I shall go and see ma, and tell her all, my poor Mouse, my poor little
sad Mouse; fulfilment in the little things of life the wise men say.
How will we afford all those nappies? We shall tear up sheets. How
will we get warm clothes? We shall steal thick pieces of cloth and
make them!*
*But -------- how will Mouse tolerate me? - Ah! There's nothing to
tear up! There's nothing to steal! How? - A question for the wise
man, yes there's a question for the wise men! How? - By reading
George Eliot? - No, then How? "Why by stealing thick pieces of
cloth- and tearing up old sheets!" Yes of course! Perhaps you're
right whoever said that, perhaps your right!*
*I've just told someone that I'm going to marry you in a few weeks,
"Oh yes!" she replied, (you remember flood pots bit) "You'll make a
good couple indeed- Ha! Ha! Ha! Ha! Oh dearie me! It's funny!*

Ho! Ho! Ho! Ho! Ho!Ho!Ho!He!He!He!He! a good couple! Ha!
He! He!
Actually mouse! we will make a good couple! I've thought of a
marvellous invention. I've concocted this muzzle affair, with
blinkers, it does two things at the same time, - it impedes your
complaining, as well as annihilates completely any question of
seeing at all! Never mind seeing sideways; so that's the end of your
Georgie Hamilton's and I am well aware that a pair of eye patches
and a piece of Elastoplast would suffice equally well but this
machine is a work of art- an aesthetic wonder at the same time.
Wouldn't it be good if your ma and pa said - Robert come down with
your things and live in the house.or come down and live in
Cornwall; listen mouse!

Is there no question of us getting married in Cornwall? We could do
it at a reasonable distance from Pa's neighbours and all should be
well! I wonder if we could lie and say that you are resident in
London- and marry in a church. Here? still I'll find out about it, in a
way I'd prefer to ease the marrying till after the kid, I know it
wouldn't matter if you were dead struck whether we married in an
office, a church or a field but you're not struck! So we might as well
make your memories - loathsome as they will be, as pleasantly
loathsome as possible.
Please don't be sad mouse, I want to make you as happy as I can, I
know that there's no question of me making you truly happy; but it
could be worse, although I know it should be better. But after all
mouse the thing you want is rare and God-given, so rare in fact that
what tales there are of it- are legend.
Still- your liking for me will not be god given (I know all is one in
the eyes of god- but a jacket should not and could not take the place
of a lion) so it depends on how much 'YOU' are capable of insight
and experience. I'll send this now - and hope all goes well.

*I wrote to your mother to try and somehow communicate, instead of
remaining estranged, - I don't suppose it helps - (forgive the
audacity) but it's something.*
*Please! Please! Look after "it" be gentle with yourself, all my love to
the two of you.*
Robert X
I'll write soon.
Be careful!

Letter 3

To my dearest Mouse, with love from heap.

*If there be condensation and misty dishonesty. Then the child born
will be bitter morose and sad - but be there a blue sky and a view of
clarity then the offspring will be bitter morose and sad. The children
born of different mothers will be the same my dear because their
grandmother is you! Can a child be born of a blue sky and a view of
clarity with earth such as you in its ancestry? The child would be
orphaned at birth-cast from your household of winter hurtled into
the hideous abyss of spring - onward to the loathsome prospects of
summer; Nay - the loved one's you produce will wallow in warmth
of ice, sleep in beds of bramble, they will eat scorpions and drink
acid, and be buried in some unknown igloo.*
*Verily- the love of a mother is great! For winter loves her children
as doe's summer, deceit loves hers too as doe's truth.*
*Soon my dear with their next nine months of lies your children will
heave and strain- they will give birth to yet more children, and you
my beautiful one will be a great-grandmother! Verily Winters Womb
needs cleaning.*
*But look! Do you not see winter tottering outside the pub of spring?
-has she not become drunker? No longer is she sober with filth!
Nay-she is drunk from the mug of honesty! - "What is this I see" she*

24

cries! "I see a blue sky and a view of clarity"! And her children carry her home crying "Mother is ill"! Yet her drunken mirage lasts only a little while, for once sober she rains - hails and snows on a new country, for the old one is either to sodden, and she has left her step-sister monsoon to look after it, or...........it has excepted summer.

Letter 4

Mouseling!
I am about to go to sleep on the lounge floor it is 12.15, I dare say your asleep, (wish I was with you) The other sheet of paper was written in a poetic mood on the train to Paddington - hope you can decipher it, doesn't matter anyway.
I hoped I could send you some dough - but - ever so sorry - can't!
Can't wait to see you again - (sounds slushy I know).
from struck one to unstruck one -
Love
Robert
P.S: Don't make me too sad! See you Saturday!

Letter 5

Dear Mouse,
It is 8 o'clock on a warm cool evening, Monday evening, to be precise, I am sitting in the garden des Tuileries, surrounding one end is the Louvre, at the other, -Trees, there is a gap between the trees through which can be seen running straight down, the very elegant Champs Elysees; from where I am sitting, I can see the Place de la Concorde in which stands the Obelisque, behind that, is a blue shape, can be seen the Arch de Triomphe, slightly to the left, one can see the silhouette of the Eiffel Tower, (forgive the way I spell silhouette, I can't for the life of me think of the correct way).

A big Red Sun is just going down behind the trees, and it's very peaceful.

I've been walking since 6 and have seen quite a bit, I intend to inhabit the Louvre for the next couple of days. I wish you were here with me, but I dare say you're quite happy where you are; I shall do some more drawing, and write again just before I go to bed.

Mouse, I've changed my mind, I shall write before I go home. I am now in a little chair it is about 9, and getting dark, my feet are supported by the rim of the fountain near the place de la Concord, all around me are little humans in similar positions, the Champs-Elysees stretches down before me with its lamps on either side going down in perspective, and disappearing at the Arch de Triomph. There are lots of statues around, and it's getting darker. The lights are beginning to reflect in the water, humans are going home. There are dozens of typical French couples roaming around; one of my sheets of paper has blown into the pool, seems funny the pools quite bare except for my floating piece of paper. It's getting darker still; more lights are flashing on all over the place, (read the next bit dramatically)...Paris night life begins.

I've been walking and walking and walking and am now lying in my very comfortable bed it's about 1 o'clock. I wondered around Montmartre, remarkable things go on mouse! Prostitutes and beggars litter the place its certainly got character, I went into a bookshop and started browsing, the manager came up to me in a tantrum, raging away in his Mongolian verbiage, I hurried off; Just a few minutes ago I went up a little alley way, only this type has doors at the entrance; on coming out a little Frenchman screamed from the distance, in a tone that meant "what are you doing in there?!" having reached me I replied in broken English, that I was admiring the ornate wood carving on the doors, all he did was 'humpf'! and sniff, again I hurried off.

The rooms ever so sweet, and I wish, how I wish you were here, but -wishing's no good. Ah well! I think I'll go to sleep, 'Louvre' in the morning. Goodnight Mouse, Goodnight. I honestly do wish you were here.

Letter 6

Morning Mouse! Is about 8.30 and I'm having brecky, then I'm off to the Louvre, every one that passes, bows his head and says 'sir' I know the word in french but I can't spell it, Ah well! I'm off to the Louvre; see you when I'm there.

Chapter Four

Drakewalls

Mouse in her own words

Robert and I had come down from London in the spring of 1964.
Robert had secured two terms teaching art at Drakewallls School,
Cornwall. We found a flat in Drakewalls House which still says Bed
and Breakfast outside! It is just up from Pearce's Garage. We had no
transport but were as happy as larks. I was in my third month of
pregnancy with Alice and had got over all the sickness, (shrinking to
a tiny size), I was rudely healthy and for a schoolteachers wife was
unconventional in that I rarely wore shoes and wore my hair long in
which I would entwine any roadside flowers that came my way.
Robert managed to ditch his smock and wore a shirt, pullover and
trousers. He brought back pupils from the school pretty often and we
all had toast and tea.

I remember the ground floor flat at the front of the house as being
the first proper place we had lived in. We were charmed by this, a

front room, a kitchen and bedroom. The first time that I made an evening meal I tripped and the whole lot fell on the floor.

Robert was popular in the school making a huge dragon that wound itself along all the corridors, in and out of classrooms. He was brilliant at inspiring the kids and made art fun.
We were short of funds and I took a job at Calstock basket factory. It was a long old stone building situated opposite the lane up to the railway station. It was eventually demolished and three or four brown houses now stand on the plot. People who worked there remember it fondly. I detested it. I worked in the drying room where one stood on a strong wire mesh floor, where heat came through to dry the columns of strawberry baskets made for fruit produced in the Tamar Valley.

My job was to separate these columns into single baskets – all day – all day looking at the vast clock on the far wall which was the slowest clock in history. It was a job to separate the wet baskets which had racks that caught your skin and I dripped blood, each evening coming back from Calstock by bus with horror movie blood stained hands. Little did I realise that 55 years on, I would be writing this in that same village having had many children and grandchildren and a great grandchild.

Cotehele House was about a mile down the road and on weekends we would walk through the fields and woods and wander round the grounds and would then follow footpaths to Calstock and sit by the river, this same river I can see from my window. Shopping, I used to get at Gunnislake, never thinking about the steep hill going back home. We were like young ponies. I would walk up to St Ann's Chapel to the Post Office and doctors and have a word with a rather lonely white horse in a field. In the autumn of 1964, I went into Tavistock Maternity home to give birth to Alice. Robert came and I remember him very elated. Alice was beautiful. I remember waving

to Robert from the upstairs maternity window. I then went down to my parents' house and we left for London to live at the Hotel Shemtov in Cricklewood.

Chapter Five

Hotel Shemtov

It seemed a long time that Mouse and Robert lived at Drakewalls. Miss Brooks was a kind landlady and she and Robert walked for miles especially down to Cotehele House. It was a rather strange period for them as it was according to Mouse, as near normal as they ever got. Robert taught in the school and Mouse worked in the basket factory and they ate normal meals on a normal table with the windows not blacked out. The essential difference was that Robert didn't paint in the flat. He painted at the school, a huge mural on canvas of the children. She never knew what happened to it. Mouse floated around with wild roses in her hair and barefoot. They were very happy. They were gypsies and the idea of a baby seemed to fit in quite naturally.

Looking back, Mouse felt a tremendous affection for a painting of white horses on the wall that she focused on while giving birth in Tavistock. Robert arrived in the evening and left Mouse a lovely letter. He had found a flat in Fitzroy road, in London, near Primrose Hill, quite a sweet little flat, possibly he asked Ma, (his mother) for the money. Ma had a tempestuous relationship with her sons. Robert asked and Ma gave. She had extraordinary presence and according to Mouse, each daughter-in-law progressively viewed her differently. It was new to Mouse because she lived with Ma for six months in the attic of Hotel Shemtov.
When Mouse first met Ma, Robert led her to this large ultra-feminine room and she was sitting up in bed. She spoke to Mouse as if she was an undesirable insect but at the same time polite and Mouse felt as if Ma was very jealous and resentful of her. Ma's life was her boys and her great wish was that Robert would emulate her

grandfather who was an established artist. She despaired of Robert's ragged clothes and his bohemian life.

Mouse told me, Hotel Shemtov was a very respectable Jewish hotel which had well off clients and was run extremely efficiently by Ma and her assistant, Eileen. Eileen was Irish and seemingly adored Ma. The hotel was huge and rambling with the meat kitchen and the milk kitchen, both impeccably clean. All the residents of Hotel Shemtov where Robert had been brought up were Jewish, many painted by Robert. According to Mouse, one woman used to scream down the corridor, "May you die like flies in the hot summertime!"

Mouse thought that essentially Robert and his brothers had a stable upbringing there- the father in the background and Ma all controlling. Robert's mother was kind to Mouse but at the same time she was very difficult. Her words were flying in all directions and Mouse felt she was some sort of curiosity that was unwanted around the place. Later, things improved and Mouse felt that at one stage there was genuine warmth between them. At 53, Eton Avenue much later, Ma would send parcels of delicious foods. Mouse felt that Ma was damaged. She had fled the holocaust and left behind a sister who died. Ma was a survivor.

Mouse in her own words.

Hotel Shemtov, Fordwych Road was known to me from our various visits to see Ma, as the boys called her. Robert's brothers were Jonny and Bernard who was Robert's twin. Ma was formidable with her huge size, often with a shawl draped over her shoulders. As a young girl, I failed to understand the tragic background that she had come from Germany. She was obsessed with Robert and she found little to recommend in Robert's and my relationship. It is questionable that she would have found anyone that would be

suitable. The main drawback was that I was not Jewish, and it was suggested prior to our marriage that I would become introduced to Judaism and given help towards this by the local rabbi. This never happened. In order to give us a hand with our move and a baby, the top attic rooms of the hotel were offered to us.

It was late September and incredibly hot. I was so uncomfortable but loth to be anything but appreciative. I was worried about Alice, for the heat was overwhelming but I hooked up all sorts of curtains to keep the sun out and walked her out in the pram around Kilburn until the cooler air of evening came. It was not conducive to feeling calm. I became accustomed to the milk and meat kitchen. Eileen, the Irish Maid was Ma's main stay. The hotel was beautifully run with several maids all working to ma's command. I never saw her anything but fair and I feel that she made a life for herself there and was highly respected. She was frightening, her whole being in discontent. Her life in pre-war Germany had been full of promise and she was expected to be a concert pianist. Sadly there was no piano at the hotel.

Robert and Alice our daughter and I were one item. We desperately wanted a place to do our own thing and feel relaxed. Looking back I could have involved Ma so much more but it was an uphill battle. Robert asked her for money for a flat and she always gave it. This troubled me but that's how it was. We moved to a small street off Regents Park Road. It was a lovely area, just around the corner to where we had lived in the ballroom. Unknown to me, Sylvia Plath had lived about 2 doors down, but possibly the year before we moved in it was where she committed suicide.

I painted the sitting room Oxford blue and tried to give some semblance of a home. The trouble with these small flats was that there was nowhere for Robert to paint. I don't remember where he did go because I never remember a day passing without him

painting. Primrose Hill was around the corner and also on a calm day one could hear the lions roaring at the zoo which troubled me greatly. We were the ground floor flat and upstairs lived Pierre Von Grunewald and his wife, Jo and little son of three called Jay Jay. Robert and Pierre got along and became good friends. Pierre was a writer and I remember his writing so tiny and immaculate. He was not the most practical of men and one day, with the wind tearing through a broken windowpane, to my surprise, I found him sanding a floorboard to a perfect finish. Eventually for the same reasons, or perhaps it was because Robert had no painting space there, we moved to 53, Eton Avenue, perhaps the most beloved of all places that I lived in London.

Chapter Six

Reflections

When back in London, Mouse and Robert settled in various flats
such as Fitzroy road and Eton Avenue. Previously they rented their
flat in a ballroom, a huge place off Regents Park with no facilities.
They shared it with Des, Robert's best friend. Des was West Indian-
a poet and a beautiful man. At one time, Mouse had fallen for him
which led to them kissing up in the loft among the chimney pots
looking over Primrose Hill. Later, Des died in a tragic road accident.
At that time, the young men used to play, "Chicken" aware they
were the last to jump from passing cars and poor Des was one day
tragically caught out.

Fitzroy Road was clean and Mouse and Robert painted it dark blue.
Pierre and his wife Jo lived upstairs and Robert and Pierre became
good friends. The flat had a small garden out the back for a pram
and Robert painted while Mouse took me up to Primrose Hill. It was
very much London life, happy, painting, books, reading. They had a
spell of high living when a woman called Jackie decided to be
Robert's patron. She was very well off and lived in a mews off
Regents Park. They went to dinner there several times with
illustrious guests such as Douglas Fairbanks Junior and other film
stars. The dinners were sumptuous but for some reason they always
felt they were children trying to be grown-ups.

Mouse told me they used to do crazy things together like exercise
madly outside in the cold on wintery mornings. When they were
very poor, they used to have to eat the remainders off people's plates
in restaurants or order food and quickly run out before paying as
they were very poor at the time. It was at this time that Robert began
to meet friends that would also be friends for life. One of those was
Alex Donoghue who bumped into Robert near Eton Avenue one

35

afternoon. Alex Donoghue was a wrestler, with black curly hair and sparkling blue eyes and the biggest pair of shoulders one could find. He lived in Fellows Road with Betty. They were from the north and warm as toast. Robert and Alex were boys together and had great times.

Mouse was twenty-one years old and worried about paying the rent and food to look after me. She worked for a while in Tesco's which was one of the first Tesco's according to Betty but one day at Tesco's, Mouse was presented with an Ox tongue at the checkout and the awful sight of it shocked her and she left immediately never to return! Alex eventually became one of Robert's closest friends.

In later years when I was writing this book, Alex wrote to me and after some correspondence he said he would write down his memories of Robert and how their friendship began. It was at this point I put him back in touch with Mouse. They were both living in Devon but neither knew it throughout those years. Alex has since contributed to this memoir with his memories.

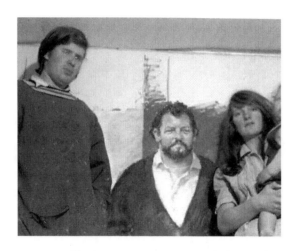

All of us next to a portrait of Alex

It was when Robert and Mouse lived at Eton Avenue that many people came around to our flat. Robert's murals stretched across the walls were half finished. Things like cooking meals in the house didn't come high on the agenda. Mouse did make spaghetti but she thought apart from toast, it was the only thing she could make. She and Robert tended to eat in cafes such as The Falafel House being the favourite and Robert would pay with paintings and designing menus.

They would wander to The Loft in England's Lane for a meal at The Witches Cauldron or The Moon and Sixpence, 2-3am in some cafes and they would take me in the pram with them. They were pretty casual parents but we were all happy that way. Aury used to call round and Myrna his partner used to teach Mouse how to crochet and play the guitar. Mouse became good friends with Myrna.

Chapter Seven

Eaton Avenue

Mouse in her own words

London, 1965 was exciting. I was twenty years old, married to a man that adored me, and who I reckoned was a genius in his field, was fun, captivating, unusual and madly good looking. I felt like the luckiest woman alive. Alice was a few months old and was the easiest baby with blue eyes and an enchanting laugh. We spent time being silly, popping up at the end of the pram to the gurgling giggle. Life was easy and uncomplicated. We did what we wanted and

when we wanted. To get Alice wrapped up and bundled in the pram was a regular occurrence and we would be off to The Moon and Sixpence for a cup of drinking chocolate.

53, Eton Avenue was our basement home with French Windows leading out to a wild back garden. If I look back, it was always summer. We sat out on the uncut grass and people drifted in and out; Roberts's great friend, Alex Donoghue and the West Indian boys upstairs that played endless Stevie

Wonder songs which filled the air. Paddy next door would be smoking roll ups and was often seen climbing the drainpipe up to his third-floor room.

They were huge Victorian houses and led from Finchley Road at one end of England's Lane, Belsize Park. There was an assortment of little shops and The Washington, a large, pink pub that we never went into. The Loft upstairs from an old news agent was our meeting place where we played chess. Robert sketched often to pay for our lunch. Martin Carthy, the folk guitarist was there a great deal and we were all commenting on the new singer, Bob Dylan from the States.

Eton Avenue was lined with trees and the lamps shone with iridescent light filtering through leaves, a vivid green. Our flat comprised of one huge room with a double bed, an old piano which Mrs Lumley up the road gave to me. I used to wash her and read to her and she would get mosquito bites in the summer and she would say, ''Scratch them until they bleed''. She couldn't use her hands. And I used to do this for her, trying not to show my repulsion. She liked me so the piano arrived and an assortment of rubber plants and geraniums. Alice had a cot and several large paintings hung from the walls. There was a tiny kitchen with a gas stove and nothing else, not even a work surface or a table, and we had a bathroom with a gas heater that we never used for fear of being blown up. Life was primitive and we were rough and ready. I wore Roberts's old shirts

and his trousers with string around to keep them up and we rarely looked in a mirror. I don't think we had one. We were happy and that was all that mattered. It was here that Robert painted me, Alice and friends in *Group at Eton Avenue*.

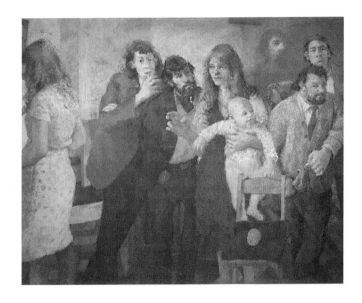

Chapter Eight

Robert Lenkiewicz by Alex Donoghue, 1963—2002

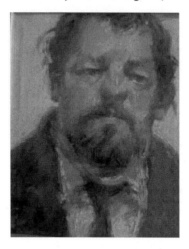

Painting of Alex Donoghue by Robert

Several weeks after moving into a flat in Fellows road London
NW3, I was walking home along England's lane late one afternoon
in 1963, when a tall well-built fellow walking in the same direction
overtook me. As he passed, I glanced up at him, he was six feet plus,
[I am five feet seven.] He was wearing a poncho that had been cut
from an army blanket; and I could see he hadn't shaved for a couple
of days.
[Robert didn't have a beard in the sixties.]
His cord trousers, large boots unkempt long floppy hair and hands
were spattered and stained by different colour paints, as he brushed

passed me, I could smell the paint on his cloths. He reminded me of 'Gulliver.

As he passed by, he had a good look at me! I thought he was going to speak. Then changed his mind.
I instinctively responded to his glance with a quick Nod of the head; he was walking at a good pace obviously in a hurry, then he looked back at me without stopping before disappearing around the corner into Steels road. By the time I climbed the steps to my front door, I saw he was standing across the road looking directly at me; definitely watching me through squinty eyes. I looked straight back at him, thinking what he is up to. The area had its fair share of alcoholics etc., so he might be after a few bob for a drink or whatever. Although there was something about him that seemed different, exactly what I wasn't sure of at the time!

I opened the front door then closed it without going in,
I thought whoever he is; he's mistaken if he thinks he can intimidate me with his size, and unblinking stare, walked down the steps and headed towards him, when he realized I was going to approach him he strode off in the opposite direction. I stood for a couple of minutes watching him striding up Fellows road; 'Gulliver' came to mind again,
I half expected him to look back, but he didn't, he suddenly turned into a side street and out of sight. Maybe he had mistaken me for someone else I thought, it had happened before, so I decided to forget about it.

I was a strong well-built twenty eight year-old, who could take care of himself, so I wasn't going to lose any sleep over the incident.
I knew people in the area who had interests in west end night clubs etc., and was seen in their company from time to time, many took it for granted that I was one of their, Heavies! Which I was not! So there were those, including Robert, who regarded me as having a

reputation for cracking heads. A reputation I must add, that was untrue.

[Robert at that time believed I was one of the 'Heavies. And that was his reason for not approaching me directly to sit for him.]

During the next couple of weeks, I saw him almost every day. It's strange how one can be unaware of another person's existence, until encountering them for the first time accidentally or otherwise, and thereafter, that person seems to be on every corner you turn. At least I find it so, and still do, as I did in Robert's case!

He was always in the same clothes whenever I saw him, carrying books, strips of wood, or some other piece of bric-à-brac more often than not in the company of people down on their luck, many of them known in the area for being drug addicts, alcoholics, or mentally ill. I assumed he was one of them; exactly which habit he had to satisfy I wasn't sure.

Whenever he saw me, he would study me for a minute or so keeping his distance.

I decided to let it go for the time being, but I had made my mind up to corner him and find out what exactly he was up to. I wasn't in the habit of letting a stranger study me as though I was some kind of curiosity. It never occurred to me to ask friends if they knew anything about him, even though he was now beginning to bug me.

One particular day when I saw him on the other side of the street, I suddenly crossed over without warning, and confronted him. He had no time to move off; he looked genuinely surprised at my action.

What's your problem I growled at him?

Every time I turn around you are there scowling.

[He told me later he thought I was going to hit him.]

Sorry, he said, I don't mean to scowl at you, -- honest, ---- my name is Robert Lenkiewicz, I paint, I live just up the road on the corner of

Eaton Avenue with my wife and daughter, anyone round here will tell you.

I was still glaring at him, when I asked him sarcastically,

What do you do? Paint houses?

Sometimes he said, if I have to!

What you after?

Being careful, in case this big guy suddenly decided to take a swipe at me!

Whenever I see you, you're glaring, looking right through me. Weighing me up. If you are you planning to mug me. Think again pal,

Do you get what I am saying?

Or If you're thinking of putting the bite on me [asking for money] by giving me some old sob story, forget it ,I've heard them all before mate, so don't think I'm going to be your benefactor feeding whatever habit it is you have, Understand!

I said all this with the confidence of having had a lot of experience being around hard cases. And people from the world of wrestling most of my life.

His reaction to my words of wisdom was what I became familiar with over the next forty years of friendship with him.

Drawing his head slightly down on his chest; chin tucked in, eyes wide open and a long slow grin from ear to ear.

No-- No, he said I am not violent and I'm not an alki, or a drug addict. I paint portraits, and I would like you to sit for me, if you wouldn't mind.

What do you mean sit for you?

I would like to paint your portrait he said,

What you talking about paint my portrait, what for?

I think you have an interesting head he replied;

I thought this joker is taking the Mickey. I was convinced someone wanted to have a joke at my expense and was trying to set me up. I told him to get lost, and if I caught him hanging around my space

eyeballing me, again one of us would end up in hospital? Do you get what I am saying? I warned.

He genuinely recoiled at my aggressive warning, Apologising as he backed off, after a few yards he stopped and looked at me with a fixed gaze, I am not an aggressive person, I don't look for trouble, most people know me round here, if you change your mind I live over there, pointing towards his studio on Eaton Avenue. And he walked away.

[I couldn't understand how a big guy like him could take as much flack as he did from me without retaliating. I thought he must be a bit of a wimp. [How wrong I was, Robert was far from being a wimp, I have never respected anyone as much as Robert.]

The following evening I was having dinner at a friend's home in Fellows Road, who was giving a dinner party for a local artist, Ray Crompton, who had some of his paintings hung around the room prior to being exhibited. There were about ten guests in all. When I mentioned the name Lenkiewicz, all ears pricked up.

You know Lenkiewicz? Said Crompton

No, but he wants to paint my portrait.

That's interesting, when are you sitting for him?

Everyone seemed to be impressed and keen to hear more, so I decided not to declare

I told Lenkiewicz to get lost!

Of course, you agreed to sit. You lucky so and so.

I told him I would think about it.

You didn't agree right away?

When are you seeing him again?

Someone said, 'I would have jumped at the chance' I hope you are going to tell him you will sit before he changes his mind.

What is the big deal sitting for Lenkiewicz? I asked

He is a young man with a big talent who will be recognised as one of the world's great artists one day. Many regard him as a genius

45

now. His work is very mature for his young years, and then there are others, who see him as an odd ball, who hangs out with all the riff raff he can muster. A general nuisance in the area and would rather see the back of him.

I have had one conversation with him said my friend and host; He is a very unusual and a talented man, as you will discover when you sit for him. I am sure you will find Robert very different from the person you think he might be.
[I didn't realise at the time what an influence Robert would have on my life!]
I now wanted to know more about Lenkiewicz and wandered if I just might have scared him off. Only one way to find out and that was to look for him next day. I didn't have to look far; there he was as usual patrolling the locality.

I had no knowledge of painting, apart from knowing the Mona Lisa, was painted by an Italian. And I had enjoyed the movie Rembrandt which was a coincidence as both influenced Robert at one time. I wasn't bothered if he painted my portrait or not, I had heard so much about him that evening. I wanted to find out first-hand if he was a con man or the genuine article.

[I was to discover, eventually, my friend Robert was both.]
Several of the guests were now asking my opinion about Lenkiewicz and other artists in and around Hampstead who I had never heard of, let alone qualified to comment on them, or their work. It seemed to me they assumed because I had been asked to sit for Lenkiewicz, he had bestowed on me by some mystical means all I needed to know about the arts and artists. As Robert would say, "there's nothing funnier than folk."

The next day when I spoke to him and asked if he was still interested in painting my portrait, he seemed genuinely pleased I had changed my mind and attitude.

I asked him when and where he would like to start the painting, and what kind of clothes he would like me to wear for the sitting.
You're ok as you are, and I would like to start right away! He saw the surprised look on my face, saying it will only take an hour if you have the time.
I said "Fine, let's go!"
That was the beginning of our long friendship, I have lost count of the hundreds, and possibly thousands of times I willingly sat for Robert.

He had a canvas already set up on an easel in the centre of the studio; He placed a chair behind, and to one side of the easel asking me to sit on the chair. He then gathered together, a jam jar of brushes, rags, a mirror, tubes of various brightly coloured oil paints he squeezed on to a pallet and I could smell white spirit from the jam jar as he placed everything on a chair.

[Robert gave me the palate, which I still have]
He collected all the tools he needed without speaking, and almost in slow motion as I watched him move about the studio. The walls of his studio flat, were covered from floor to ceiling with life size murals and paintings, I had never seen anything like them in my life and here I am surrounded by these wonderful paintings about to have my portrait painted.
Robert found it amusing when I asked him several times, if he had really painted all the work in the studio. I was totally gob smacked. And here I am having my portrait painted by a guy who I had threatened to put in hospital if he bothered me again. I felt very silly.

47

He asked if I would like a cup of tea, I said "no thanks." By the time he came back from the kitchen I had, had a very good look at his paintings and even I who knew nothing about art, realised he wasn't just a painter.

He sat on a straight backed chair facing me with that penetrating look, patted his thighs with both hands, then sipped from a mug of tea, took a deep breath, exhaled, gave me another long look, then studied me again through a mirror for a few seconds then made his first statement on the canvas. It was the first time I had ever sat for an artist, let alone a genius.

My dinner party host was right when he said; I would find Robert a different person to what I thought he might be.

Robert asked many questions during the sitting, the more questions he asked the more personal they become; questions, I would normally have refused to answer, but I felt comfortable with Roberts's inoffensive technique, casually enquiring like one would of an old friend you hadn't seen for some time. What kind of work was I doing now, was I married, did I have any children, etc. Wanting to catch up with all the news of a pal he hadn't seen in years. Obviously, he wanted to know as much as he possibly could about me and as quickly as possible.

I was surprised how much information I voluntarily gave about myself. By the end of the sitting, he knew more about me than most of my friends. The hour passed quickly.

You can relax now, he said, leaning back in his chair looking at the painting through half closed eyes.

I asked if he was happy with the painting so far. He nodded his head slightly, I wasn't sure if it meant yes, or a no. He smiled, said "Thank you, can you be here tomorrow, about the same time?"

Should I wear the same clothes?

If it's not a problem, he said.

Do you mind if I look at the painting… before he could answer, I said, I've changed my mind, and I'd rather wait till it's finished. You can look at the painting any time you wish, he replied, as he went to the kitchen to make tea while I, had a closer look at the biblical figures on the large mural, and another very large painting that was on the opposite wall, showing Mouse holding daughter Alice, Robert's brother John standing with two other people, a shadowy head minus body with large eyes peering out at the observer over Johnny's [Roberts brother] shoulder. Mouse again, without Alice, walking out of frame to the right of picture; it looked to me as if this painting needed more work before it would be finished.

When he returned, carrying two large mugs of tea, I asked how old he was when he began to paint.
What inspired him to paint the larger than life biblical characters in the mural that I felt would make a great back drop for the opening of a, 'Cecil B de Mill' epic 'Cinemascope' film, [Famous American film director]
Robert saw the 'De Mill' films, including 'Quo Vadis', 'Ben Hur', 'Sampson and Delilah' and many others.
Why don't you contact the film companies, I suggested, offering to create murals and special scenery for epic films and get well paid for doing what you enjoy, you have nothing to lose I said. Why not give it a try?
Robert thought I was jesting, and laughed at the idea, I said I was quite serious and offered to contact the film companies on his behalf. I could see by the look on his face, the thought of painting very large murals intrigued him; he mentioned several films he had seen that had enormous murals in the opening scenes.

When I repeated my offer to contact the companies, hoping to raise his interest further, I asked, how he would set about painting a blank wall the length and height of a film studio given the opportunity?

That is quite an exciting thought, perhaps one day I will find such a wall?

I realised at that point he wasn't too interested in my idea so I jokingly said, I could see him swinging across scaffolding from one side of a mural to the other like, a Quasimodo which amused him no end, and suddenly he bowed low twisting his body out of shape, his face contorting, mouth, and one eye tightly closed, swinging both arms from side to side as he moved across the studio murmuring, in a husky voice and slight lisp, mimicking the unfortunate yet amusing 'Bell ringer of 'Notre Dame'. 'It was the Bells that made me deaf you know? Having a similar sense of humour, we both fell about laughing.

And that's where we left it; though I'm sure he enjoyed the thought of having a free hand to create vast murals for the movies. [Robert was a great mimic, his favourite, Jake the rake, the three- legged dancer.] He went on to answer my original question, what inspired him to paint when he was a boy? He said he saw the film 'Rembrandt', played by the famous character actor, 'Charles Laughton, and realised then he wanted to be a Painter.

I took this opportunity to add credibility to my earlier suggestions for painting murals for films.
Who did the paintings for the film, Rembrandt, I asked? Not Charles Laughton, he's an actor, it was someone possibly like yourself employed to paint them, see what I'm getting at? Quite, said Robert, trying not to show ingratitude for my enthusiasm, but I realised my ideas were falling on deaf ears; painting for film companies was not what he had in mind. I couldn't understand why at the time.

Several years later, he was accepted into St Martins school of art, and eventually, the Royal Academy, although he wasn't there very long, apparently the principle at the academy didn't approve of

Robert's nude self-portrait and the principle pursued the issue until a confrontation between them ended with Robert leaving the academy of his own accord. [Robert left me with the impression the principle had done him a favour giving him a reason for leaving the Academy at that time.]

Long before all this happened, when he was a boy, Robert listened carefully as he sketched many of the residents at the Hotel Shemtov, relating their worst nightmares to him, the ordeals at the hands of the Nazi's during World War Two , many of these people lost family and friends in concentration camps, several of Robert's family among them. Some of those who managed to escape the horrors eventually found a haven at the 'Hotel Shemtov' many were now chronically ill old folk, unable to cope with everyday living. Robert described to me how on occasions, he would see and hear a mentally ill old person cry out in the middle of the night to find them wandering through the hotel like an apparition, verbally abusing him while guiding them back to their room. That he had witnessed the deaths of several of these old confused people, then, having to wash and prepare the bodies ready for the mortuary, I shrugged at the idea of what was, in my opinion an unimaginable task for a young lad. A chore delegated to him by his mother.

Robert recalled his childhood experiences at the Hotel so vividly I couldn't help thinking at the time, what affect all the suffering and illness he witnessed, day in day out, may have had on him as a young lad. Was he now possibly a little crazy himself? The impression I had of the Hotel, was more of a 'Sanatorium for the mentally ill', rather than a Hotel, and Robert's home, at that time. [Robert's mother owned the Hotel Robert showed me drawings of these unfortunate male and female residents, some of these people I saw, when I accompanied Robert on visits to see his mother at the Hotel, I believe his mother and father were also refugee's from the Nazi's, Alice, Robert's mother, eventually meeting her husband to be in England.

It seemed Robert sketched anyone interesting who would sit for him, and I believe he found everyone and everything interesting, Hotel staff, Maids, Horses, Birds, Dogs, any type of animal, people, alive, or dead. Looking about the studio from where I was sitting, listening further to Robert's traumatic reminiscing, at my request, I wandered once again, what effect his childhood had upon him. Was he a little crazy'? I wasn't sure.

One thing I was sure of, he was without a doubt different from anyone I had known before, or since.

If he is crazy, I thought, I wish I was as crazy as him!

I had plenty of time to spare and was now encouraging him to tell me more about the murals, how many weeks; months did he spend working on them? including all his other works scattered around this very spacious but sparsely furnished ground floor studio/flat, with only a bed, table a couple of chairs, and one large wardrobe for personal comfort.

Almost every inch of wall space covered from floor to high ceiling with murals and dozens of finished and unfinished portraits of friends and acquaintances, studies of tramps, alcoholics, druggies, male and female, most of these unfortunates, if not all, at one time or another had, or would turn to Robert for a night's shelter, a meal, or both.

Paintings framed and unframed stood in rows three and four deep against the studio walls Watercolours and drawings scattered everywhere.

Books all sizes, Philosophy, Religion, Indian mystics, painters, paintings, most of the names and subjects I had never heard of, stacked in neat piles on the studio floor, others, crammed into make-shift shelving that sagged under their weight. Many of the books open, others bulging with shredded scraps of paper dangling like lamb tails used as bookmarks between the pages, Papier-mâché

sculptures, objects of all shapes and sizes everywhere. It was an 'Aladdin's Cave'.

Have you read all of these books I enquired?

Most of them, he replied picking up a book, that he had been reading earlier,

'Reverence for Life'

I asked who the old chap was on the cover.

Albert Schweitzer, A very exceptional man. He replied, He is a medical Doctor, philosopher, a very caring man, he and his wife went to Africa in the nineteen hundreds and built a 'Hospital' at 'Lambarene' in 'The Gabon' for the sick and poor.

Robert was about to read me an extract from 'Reverence for Life 'when I noticed on a chair behind Robert, bundles of 'Beano and Dandy comics'! Having a sense of humour, a picture sprang to mind of Robert quoting, Albert Schweitzer, on the one hand, and the exploits of 'Desperate Dan' on the other. I thought it very amusing at the time, holding back laughter. I didn't ask about the comics, I thought I'd leave that for another day.

Right now I was more interested in hearing more about Albert Schweitzer, who I knew nothing about, but, I knew a lot about 'Desperate Dan'. I wasn't very attentive at school, apart from geography and sport, now at 28, I was listening very attentively to Lenkiewicz, reading passages from Albert Schweitzer's, 'Reverence for Life'. Time passed quickly, and in the fading daylight that spread dark shadowy streaks of lost light across the studio floor, Robert carried on reading, seemingly unaware of the time and fading light, his strong sincere voice resounding through the studio as I listened and watched the shadows stretch across the floor and walls onto the characters in the murals giving the impression they were moving in the same direction as the shadows, now chasing the remaining light that hung for moments in corners on the studio ceilings, an eerie atmosphere covered the studio in semi darkness. It would have been too easy to allow one's imagination to run wild, in

this half-light, as I caught sight of some of the more grotesque looking sculpting and character paintings hanging on the walls. The fading light, adding an extra touch of the macabre. Fortunately my imagination was already occupied, listening to Robert and Albert Schweitzer.

I was enjoying Robert's response to my questions. They almost eclipsed his earlier questioning of me. He was good company, entertaining, very informative, and I just might learn something, if I listened, long enough.

I left the studio that evening feeling I had been hit in the head with a fourteen-pound hammer. The whole experience had given me a great deal to think about.

The next afternoon when I arrived at the studio for the second sitting, Robert introduced me to his wife Mouse, and daughter Alice who had apparently been visiting a friend when I was there the day before. 'Mouse', (Celia's nickname) was about to serve a simple meal and invited me to join them. Fortunately, I had eaten so declined her hospitality, just as well, as they had very little food to share.

As I looked around the studio at the magnificent paintings and portraits, I failed to understand why this talented man had no money. Although I was about to find out, or at least one of the reasons why. After they had eaten, and a few minutes into the portrait a young fellow walked into the studio that looked a little worse for ware, not quite a tramp, but obviously not a stranger to alcohol and rough living. He didn't speak, just stood inside the doorway looking at Robert.

Robert peered over the canvas, and smiled at him, as If to say I won't be a minute. Then carried on painting.

Seconds later, I could see this boozy character in the doorway gesturing to Robert with short rapid signals with his right-hand beckoning Robert over to him, He looked irritated at Roberts's lack

of attention to his urgency. The odour of stale booze and sweat in the air wafted across to us with his every gesture. I asked Robert if there was a problem and did he need any assistance?

No, no, said Robert apologising to me as he rose from his chair and walked across the studio towards this unsteady character in the doorway.

They exchanged a few words, then Robert came over to me asking almost in a whisper, if I had a spare ten bob, [50p] on me, as the chap was hungry and there was no food left in the flat to give him, Robert promised he would pay me back later. The chap immediately left grasping my ten bob note in his hand,

I naively pointed out to Robert; the money will all go on booze, not food,

You are possibly right, he said

He will spend it on whatever he feels he needs most.

That will be booze, I replied, you do realise that don't you?

Robert looked at me for a moment, then eyes closing and opening in the same instant as he nodded his head in silent agreement, as if to say,

'I know'

And that was the end of that-------------- including my 'Ten Bob'
[That situation was the first of many I was to witness, and not the last ten bob, or pound I would part with never to see again.]

Robert carried on painting as though there hadn't been any interruption, explaining as he worked, how to prepare a canvas and frame, how he selected particular paints for a project, why he used a mirror to look at his models. He showed me photographs of Rembrandt, Caravaggio, Michael Angelo, and Leonardo Da Vinci, paintings. I wasn't dim, but I realised I was way out of my league as I looked and listened with interest as he explained basic painting and Philosophy In language that I had no problem following. He took time and patience giving me answers to all my questions, for

someone who was obviously a very busy, talented man, not once did I detect him being smug, or condescending in his manner. Not that I assumed he would. I appreciated his patience and un-rushed explanations to all my questions that must have been mundane and academic for him.

Several people came and went in the next three hours, including the actor, Michael de Costa. Inspired by Robert's murals, he learned his lines while pacing back and forth and gesturing to the characters in the murals, reading aloud from his script. Any preconceived ideas I had that Robert might be an alcoholic or drug addict were gone, I realised his addictions were Books, Painting, Philosophy, People, and asking very personal questions. A few days later, at my third sitting, to my surprise and disappointment, Robert leaned back in his chair, looked at the portrait for a couple of seconds, then at me, and without warning, simply said, "Finished." I didn't know why at the time, but for some unknown reason I thought a painting took many sittings even months before it was completed. So, I asked him how he managed to finish the painting in three sittings.

Robert gave me one of his long thoughtful studying looks, and then turned his gaze for a few seconds to the finished painting. And without saying a word, got up from the chair, wiped clean his brushes with a large piece of cloth, then placed it over the canvas and quietly walked off to the kitchen. He always made tea whenever the opportunity arose.

When he reached the kitchen door, he called out,

"I'm going to make a cup of tea, why don't you have a look at your portrait?"

I stood for a couple of seconds in front of the easel wondering why he had walked off to make tea at that particular moment.

He had no objection to me looking at the painting any time I wanted from the start, although I preferred to wait until it was finished. So I concluded he went to make tea, to give me time to study the painting

and gather any questions I might want to ask him about the portrait. The cloth still wet from cleaning his brushes and draped over the portrait looked as colourful as any painting. As I tossed it to one side staining palm and fingers with paint from the brushes he had wiped clean.

I instantly realised why he didn't want to be present when I saw the finished portrait, He had given me the look of a
Boozy street fighter.
Suddenly, all 'The reverence for life' had gone from me.
'WHO THE FUCK IS THAT'
I shouted loud enough for him to hear.
I was dangerously angry at this point, 'Repeating my first outburst' adding, that's definitely not me. As I walked into the kitchen to find Robert, had gone. Slipped out through the garden gate.

I couldn't take my eyes off the image that bore no resemblance to me whatsoever. When I had cooled down and studied the picture further, I began to think is this what I possibly look like to others after a few drinks? Is this my Saturday night look? Has he put it all together from what I told him about myself? Including our initial meeting, that wasn't exactly on a par with, 'Stanley and Livingston'? I wasn't an Alcoholic, but enjoyed a drink now and again, I don't know what I expected, but it definitely was not, what I was looking at. I waited another half hour in case he returned to give me some explanation. But he didn't show up. Robert never locked the studio doors so I left, leaving the studio open to all and sundry.

Next day I had a visit from a sometimes, likeable rogue. Will call him the 'fiddler'. He asked if it would be ok, If Robert called to see me. Robert arrived mid-afternoon carrying a sketchpad and a few pencils. He stood in the doorway looking sheepish, head bowed, though I am sure he realised his submissive posing didn't fool me any longer, He was a big strong guy who preferred to be gentle and submissive rather than provoke trouble, but if shove came to push I

am certain he could handle a situation. For someone who spent a great deal of his time helping the mentally ill, down and outs, drunks and druggies, listening to their stories straight out of a 'Thousand and one nights' in many cases, the arguments, fights he prevented, the stench from spew, and urine, at least one dying drug addict, I attended with Robert, I found it incredible he never lost his cool or temper. He genuinely cared, and I am convinced he would never intentionally physically harm any living creature.

When he realized I wasn't going to attack him, he came into the flat admiring the huge room and high ceiling,
Mumbling something about one of the walls being ideal for a mural, I said forget it, and asked if he would like a drink of something. A cup of tea would be fine he said, after sitting down in what became his favourite chair; he asked if he could do a couple of drawings of me while we chatted.
I thought, he has some front, after doing what I thought was a crap portrait of me. He is now asking if he can do a couple of drawings. Why should I let you do a couple of drawings? And what was all that about leaving the studio the day before without saying a word? And that painting? He apologised for leaving, saying he had lost track of time, that he had arranged to see Mouse in the, Loft café, and was late, and she needed money for food. So he left, believing I would be ok looking at the paintings and books. He never mentioned the portrait, so I said, the painting? Is that how you see me?
It's a very good study, he said,
Would you like it?
Would I what?
Before I had a chance to say any more,
You can have it in a few days when it has fully dried. I can bring it here if you like?
I made several light-hearted comments about his offer that made him laugh.

Having witnessed the occasional 'Pub artists' drawing's that bore only the slightest wooden resemblance of the sitter who happily handed over good money to have the masterpiece hanging on their living room wall.
I thought why not accept, at least it's an oil painting, and no one could ever accuse me, of being 'No Oil Painting' in future.

So, instead of telling him what to do with the painting, I ended up thanking him. Hmmmmm? After several cups of tea, and a similar amount of drawings He asked if I would sit for another portrait, and a mural. I agreed to sit for both and dates and times were arranged.

Robert decided to put me in the foreground and to the left of the mural I have previously mentioned that depicted Mouse, Alice, and a group of people standing together, the mural was to be part of, Robert's private collection. He thought a great deal of this painting, and on several occasions told me he would never sell it; unfortunately, it was sold at auction not long after he died. I often wonder why this particular painting was one of the first to go. Many close to Robert, knew his attachment for this particular painting, so surely whoever it was that selected it to be sold must have been made aware of that fact?

Robert never took it for granted I would sit for him, he always asked, almost apologetically, as if I were doing him a favour. I am certain he never realised in all the years we were friends, that I felt he was doing me the favour each time he asked to paint my portrait, or sit for a mural, that I felt privileged he regarded me as a friend. I sat for murals, portraits, drawings, watercolours, pen and ink, crayon, some on wood, paper, canvas, cloth, brown paper bags, and cigarette packets just about anything handy at the time. Even a piece of toilet paper. I wonder if that had anything to do with me telling him I thought my first portrait was Crap?

Unfortunately many of these early works were destroyed by an irate Property owner he owed rent to in Plymouth, destroying almost all of his early work for the sake of a few pounds.

Fortunately, I have several paintings and scores of drawings of Robert's early work from the sixties and early seventies that he gave me, or I won from him in friendly wrestling, strength, and Hammer throwing contests, held in his garden at Eaton Avenue, his daughter Alice, witnessing her father and I, from her high chair in a safe area of the garden, throwing a fourteen pound Hammer, weight lifting, or wrestling. We held these impromptu games quite regularly, Robert had a very enthusiastic and competitive spirit that showed whenever he won, when he did win, I had to buy him a book of his choice, or tube of paint, or whatever, on occasions he would ask for money, and nine out of ten times he would give most of it away? When I won, he would give me a painting or drawing. I have a birthday card of Robert and me wrestling in those early days at Eaton Avenue, Robert winning of course.

When Robert realised I owned a car, or at least the finance company did, he asked if I would help transport a painting to his Mothers hotel, it was to be a gift for his mother's Birthday, the painting, happened to be the one of Mouse, Alice, Johnny, me, and others standing in a group.

After agreeing to transport the painting, he asked me to meet him at 4-30am at his studio, forgetting to mention until next morning that he couldn't stand the thought of being in a car, and would prefer to walk alongside the vehicle holding on to the Painting that had been tied to the roof, and was almost twice the width of the vehicle, ensuring its safety from Eaton avenue to the hotel, a journey of about five miles. His reasoning for the early start being, that very little traffic would be on the road, and the chances of a policeman seeing this cavalcade were slight. Or so, Robert assured me!!!

Chapter Nine

Eton Avenue - Helping the Homeless

Mouse in her own words

Eventually, more and more people called on us. They were an eclectic crowd, mainly men. Alex Milton, a painter, with a sardonic sense of humour. I wonder where he is now. There was Lofty who had just been released from Dartmoor prison with his girlfriend, Paulette, a gentle, kind girl, who was the only person to give a wedding present. I remember her gift was a pair of fresh white Egyptian cotton sheets and I was so touched. I worked in Dartmoor

prison later in my life, in my sixties and never while there saw such a scarred and hard face as Lofty. He was tall and strong and wild and he would do anything for Robert.

There were two actors, Michael de Costa who visited us and was great fun. He was uproarious and made us all laugh. He came cleaning cars with me Robert and Alice in the pram. Michael was an out of work actor and had a round smiling face and always lifted the mood. They came and went. People also sat out in the garden having tea, chatting or talking with Robert. There was also, Tony, a tall melodramatic man who spent hours playing the piano. Tony was a good looking, very tall, out of work actor. He stayed at our flat every night. Ivan was a schizophrenic and, in many ways quite frightening. He had a hang-up over urine and was always wanting to drink it. He was silent and obviously not well. Looking back, we never thought of trying to get some help with a doctor. All we provided was a sleeping bag and a roof which I suppose was something. We were looking after people with many mental health problems and addictions.

We were in quite a dangerous position but we just got on with things. While we opened up our house to the homeless, they were becoming our friends. Other friends from London used to visit us also. Stephen Wilson was a Jewish doctor. Pierre von Grunewald and his wife Jo who had a huge crush on Robert visited us. I became very aware of how enigmatic Robert was to women at this time. There was Ken Hingston who was a journalist, Nick Winkle, Derek Winkworth and Peter Sylvere, the son of a friend of mine who was a gentle lovely man. Robert admired Peter's drawings.

All of our homes were short lived in London and this was no exception. For a while I worked in Tesco's, Finchley with Alex Donoghue's wonderful lady, Betty. I used to nick packets of soup and put them down my bra. Things were different back then, no

plastic for instance. My next job was working as a hostess in a Greek night club at East Finchley. I was young and pretty and the Greek owner of the club seemed to be very jealous of me. I passed a play around the gambling table every hour and the money piled up. She gave me rotten jobs to do like clean out the fridge in the back yard in the pouring rain and she ended up screaming at me. I left, not taking my wages and I remember going back home on the tube, mid-morning, glazed with tiredness and my make up all over the place. This meant we had no rent and we were thrown out of our flat. I seem to remember police being involved and we headed for Cornwall where a farmer, a friend of my mother, Commander Milburn gave us an old cottage on his land to live in, as long as we did it up, but that is another story.

Gradually, the floor at Eton Avenue began to be filled at night with sleeping bags. I didn't question it too much. It became a way of life. But there were times when I lost it and yelled at everyone to leave. I always remember a mixture of embarrassment behind my rage as all the men started to fill my living room floor. I didn't hold on to my anger for long and the next day they would be back and it would start up again. Robert would be impervious, painting and sometimes relieved. Looking back it all seemed quite normal.

Chapter Ten

Trevauden Cottage

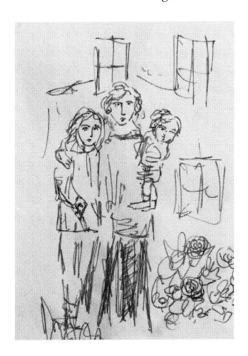

Mouse and Robert were very happy but also very poor at Eton Avenue. Mouse was always trying to keep up with the rent. She managed to pay it back for a while but then they would get into debt again. It wasn't easy to keep one's head above water and eventually they had to move on.

After living in Eaton Avenue they were offered 'Trevauden Cottage' in Cornwall, rent free for a year. Mouse remembers little of the

actual move. Robert stored many paintings with his mother and they arrived at the end of a half mile track to a quiet country road that led onto the road to Looe. It was a dear little cottage with two rooms upstairs and a kitchen and sitting room downstairs, immediately turned into another room, converted into Robert's studio.

Mouse in her own words.

I sit here early in the morning, Sunday, with Riley, my grandson, who is messing around with his 'copters' on the floor. I think Alice wants me to write about the cottage 'Trevauden' my times there with Robert. It was so long ago. I am stretching my mind back forty years to a young girl of 21 and Robert at 23. I remember Alice was fourteen months, a little rosy girl with laughing blue eyes and very blonde wavy hair.

We left London under some sort of hassle. It wasn't under the dramatic –almost siege-like conditions Robert described- he was prone to quite extensive exaggeration but it was hairy; rent unpaid etc. and we slipped deep into the Cornish countryside, one mile from my mother and father's farm to Trevauden, a plain little labourer's cottage. The cottage belonged to Michael Milburn and Elspeth Spotiswood. They were farmers with a large family, and Elspeth painted. I remember them both in their early forties, very good looking and charming. They gave us free rent for a year as long as we decorated the place. Robert and I saw nothing wrong with the way they had decorated and had absolutely no idea of decoration. I wasn't too sure of my taste in décor at the time and if extended materialistically, would dream of smoked glass cabinets and G Plan furniture. I had not acquired any sense of taste except in clothing where only cotton or wool would do.

So, Robert and I moved into the cottage, two absolute innocents with paint, easels, baby and some blankets. The cottage was a mile

off the road and cars were things other people drove. It is still a complete miracle to me that I now drive. So there was a huge trudge to the road and about 3 miles to the nearest village, Lanreath, where there was a shop, a post office and a pub, 'The Punch Bowl Inn'. In a way it was the nearest Robert came to my own upbringing. I was a country girl and had a deep awareness of trees, wildflowers, grasses. I had spent all my childhood 'out'. We had no electricity- a battery radio, but the trees, flowers birds and fungi, streams, gulleys were my playground. Robert was urban Cricklewood in 'Hotel Shemtov', Fordwhych road, immersed in old age, Irish maids and overall the Jewish culture. London was his heart.

In Trevauden, we were completely alone - the three of us, for the very first time. The sitting room became the studio; canvas palettes and almost immediately Robert started painting a large canvas, a painting of me holding a ball of blue wool- a painting he reworked many times- the painting he called his silver painting having that silvery quality he was looking for.

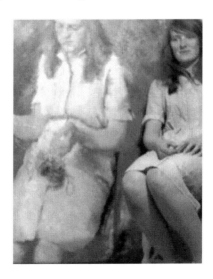

There were two rooms downstairs and a kitchen. All of it was rather dark. The stove in the kitchen was faulty and if one put a metal spoon into a pan of water you got an electric shock. There were also rats that merrily ate into the sack of potatoes. None of this bothered us, we had never heard of Weil's disease and we made the rats welcome. The staircase had old wooden panelling which was broken. We mended it, our attempt to show we were eager decorators. This panelling was previously covered in hundreds of layers of wallpaper, we decided to strip away. Alice would tuck her arm in mine and with old scrapers we would pick away at the wallpaper. The eventual result was rather tired old wood with scraps of glued paper hanging from it that we left- it held little interest for us after the initial enthusiasm.

Upstairs was cosy-Alice half asleep- we were casual householders- as long as we ate and were warm and more importantly had books, we had no rules, we didn't understand what they were. The only thing I look back on and regret and I didn't let Alice do was pick the flowers along the track. Looking back at it I think- how silly- a little girl having pleasure. She didn't mind but looked at me puzzled- it seemed so obvious that they were just asking to be picked.
Our days were idyllic. One of those times when you felt that the sun always shone.

We acquired two bikes and Alice went on the back in a little seat. Sometimes we would cycle down to Looe or Polperro, a good seven or eight miles and back. I was into making jellies with flowers embedded inside the jelly, primroses and in the summer roses and nasturtiums. We would hike to the village shop and bring back our stores for the week and back the fire up with logs on rainy days and sing and dance to the radio. We would dance many evenings. It would start off as me with my shoes off standing on Robert's feet and then we would just dance! When Robert painted which was one

third of the time, I would read aloud Tolstoy and Dostoevsky. Hours would slip by and we would be in amongst the silver brides and snow of Russia like Doctor Zhivago.

Alice was easy. She was happy - She had little red Wellington boots and the three of us would walk for miles and then I would put her on Robert's shoulders. She drew a lot and pottered around outside quite happily. Sometimes we went down to my mother and father's farm for a good meal. Once we left there pretty late and were walking up a massive climb to the main Looe Road. Robert was carrying a sack of potatoes and there was a full moon. Something came over me and I said, 'give me the sack, Robert'. He took Alice and I felt myself being pulled up the hill with this sack in my arms. It felt as if I was floating up. It took an hour to walk home and a 52lb sack is no light weight. I remember, the moon was so beautiful down there in Cornwall.

Occasionally we would go to the Punch Bowl Inn in Lanreath and talk to someone called Reuben, a gypsy. We didn't drink. Alcohol held no charm. Visitors came down; Milton, a Jewish painter friend, Alex and Betty with their laughter and energy. Irene Flower and her daughter Elienne visited. Irene was very special to me. We wrote to each other for many years. She was the mother of Peter Sylvere a fellow art student of mine at St Martins. He took Robert and I back to his flat and we met her. She was Russian, with perfect English. Her mother lived in the flat and two of her five children. It was a graceful gentle room with long blue velvet curtains and books and a table overlooking a park.

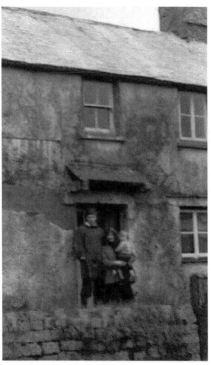

The three of us at Trevauden Cottage

Elienne was small and utterly grateful. She had been a model for Picasso. She was deeply intelligent and warm and interested in the unusual. We loved each other. On the visit to meet Irene, it started off a little stiltedly as we had always been on her home ground. I felt awkward and mispronounced a word and we all started to giggle and it ended with me and Irene on the floor dying with laughter. Nothing like laughter for breaking the ice! Robert painted her and as she left in the car, she looked back at me with her beautiful enormous eyes and it was the last time I saw her. She died shortly after.

When we were at the cottage, Westward TV came to film Robert and the paintings and a correspondence with Pete Bryant a lovely

guy from Stoke and his wife Dyl began. Ultimately, when we moved to Plymouth, they found us a flat and asked us to Sunday lunch every week with all the family.

And so that year passed, gentle and happy. Making my way along the track I felt sick and realised I was pregnant again. I felt so happy, deep in our little cottage with Alice and Wolfe to be and Robert. I really would have liked to have stayed there forever, that little place of bluebells and ragged robins and golden sunshine.

Chapter Eleven

Rectory Road

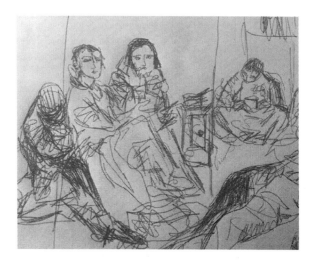

Mouse in her own words

Later on when we had moved to Cornwall and after we had lived at
Trevauden Cottage, we moved to Plymouth at 24, Clifton Street,
where I gave birth to Wolfe. Again, we were evicted, with a front -
page newspaper article showing a nude painting in the window. We
did misuse the house. Poor Mr and Mrs King downstairs had a
dreadful time with us. We never paid rent and our many visitors
used to go through their flat downstairs to use their toilet. Lyn
Brogan, a friend of mine, a skinny girl and training to be a social
worker helped me try and keep things steady. We were a nightmare
and it is a miracle that we found another house.

Later on, Rectory road, also was a similar situation. People started visiting us once again and those who had no lodging stayed over with us. It was different from London as the majority of people staying with us were not only homeless but was also alcoholics and drug addicts. Mostly it was poor older men who were unable to get into the Salvation Army. Our home became a homeless hostel really but we were bringing up our children there also. I know it sounds crazy but we just took it all in our stride and did the best we could. Nothing terrible ever happened. We just got on with things. Monica and I were being mothers to everyone and Robert was dealing with the homeless in many ways, setting up warehouses in the city centre of Plymouth.

We also fed everyone and washed their clothes. One man called, Sid, was homeless and we gave him one whole room to himself. Looking back this seemed very generous of us. We must have had good reason. Space was gold dust. It was mayhem! We looked after the children and catered for these old men who were often incontinent. We all caught scabies. In this day and age, the children would have probably been whipped away from us! It was crazy but strangely enough amidst all the difficulties there was also a lot of fun! We played music such as Vivaldi and The Beatles and we all danced and fed the babies with their bottles out in the backyard in the sun. I remember buying from the Co-op a Canon gas cooker on HP. It was the pride of my life and I cleaned and guarded it with my life. Eventually it succumbed to all the spilt soup and ended up as an encrusted black old thing.

People stayed but they also passed through. Alcohol was the mainstay of most of the men. The Bishop was with us for a while with his Oxford English and wild opinions. Most of them drank straight from the bottle but if they went into a pub before coming back to no 7, it was the United Services or Star of the West in Union Street. It was at that time that Robert and I went our separate ways. I

then met Jim and moved on with my own life and Robert and Monica became an item. Jim became a close friend of Robert and he was also my daughter, Becky's father. Between me and Monica, we had four children at one point in that house in Rectory road and there were three bedrooms and two rooms downstairs and a kitchen. I lived in the attic. I look back on this now and wonder how this ever could have seemed normal. We had no curtains and some thoughtful neighbours came over with armfuls of material to put over our windows.

Overall, my memories of Rectory road are positive. However, I remember my parents from Cornwall, once coming over for a visit and when they saw how I lived they were totally outraged. At the time, I was puzzled that they just didn't get it. There were colourful characters. The Bishop who must take the accolades for being outrageous was a well-educated and reputedly an Oxford don who for one reason or another ended up on the road. He would recite passages from Shakespeare and stare up at the sky, ranting about aeroplanes which he was deeply suspicious of -"little sardine tins" he called them. And there was Corky, a loveable Irish man who told us all very funny jokes and kept us laughing. There was Gyp with his dog. Gyp was on heroin and had a vicious face. There was Winnie who was also homeless. I remember one night she screamed and ran out like nothing else when she discovered Robert and some others had dug up a skull and she had found it inside the roof. She totally freaked and who can blame her! I remember there was Joe, a surly man and a heavy drinker who viewed the world suspiciously. Goodness knows what they all thought of us. As long as they had somewhere to sleep for the night, they were content.

It was rough back then with the hippy culture just beginning. I remember sitting with Monica in The U. Services and singing along to the song, 'If you're going to San Francisco, make sure you're wearing flowers in your hair' and we would return to Rectory road.

It was mad there really. Again, it was that mixture of people, young blokes like Blackie who danced like a wand and Lynne Sheardown was there and a young man called Jesus was there, (named for his long hair and sandals) and Quiet John, who was indeed very quiet. I will never forget, on my birthday, they all threw a massive party for me and I ended up on The Brickfields with Jim.

Chapter Twelve

Memories of Rectory Road by Lemon

I first met your father and mother when I was 15years old. I had left
my parents after a huge fight and hitch -hiked to Bristol not really
knowing what I was going to do. After about 6 months I returned to
Plymouth but had nowhere to stay – I can't remember who took me
to Rectory Road, but I ended up staying there. I don't know how
much you can remember of those times but this is what I recall.

At the time there were lots of 'vagrants' and 'alcoholics' either
sleeping there or 'passing through'. There was an old man called
Sid who clearly had senile dementia and your father drew a
caricature of him as a tortoise. Sid thought this hilarious and showed
it to everyone who came in (he must have shown it to me at least a
dozen times). He once claimed that he had been robbed on the way
home from collecting his pension. He came into the kitchen where
Jimmy Pascoe and I were talking and told us the story of how he'd
gone into the public toilets near Rectory Road and was robbed and
sexually assaulted. Apparently, his assailant had pushed a Woodbine
cigarette into his mouth and said, 'That's to keep you quiet' as he
sexually abused him. It seems hard to imagine that anyone would
want to sexually assault him and yet he was insistent that this took
place and that the words 'That's to keep you quiet' were what was
said.

Sid became very difficult to cope with, small things seemed to upset
him – I can remember that someone bought P.G. Tips tea and he
became very aggressive saying that he couldn't drink anything but
Typhoo tea as other brands would make him ill. Sid was eventually
taking into a care home.I remember a woman called Winnie, she had
mental health and alcohol problems and the saddest persona of all

those at the house; a small, thin woman who walked as if she had somewhere to go, purposeful and yet in a world of her own. Most of those passing through were the rejects of society and although some were clearly hardened by their experiences – one man pulled a knife on me and by the look in his eye would have had no difficulty using it – most were lost and unable to cope with what the world had thrown at them. I can remember it was at Rectory Road that I met Monica.

Of course there were you, Emily and Jimmy. I can't say I remember much about you three kids other than you played out on the street a lot. And Mouse, what can I say about Mouse other than she was (and is) one of the gentlest and kindest people I have ever met. I have no idea why your father took the 'waifs and strays' of Plymouth in the way he did – maybe you know. But Mouse was always kind and caring to everyone – I really don't know how she coped, but then again Mouse seemed to have an endless capacity to care for others.

When you look at the film clips of your father, he always projects himself as very serious, and he was when discussing serious topics, but I remember us both giggling like a couple of kids over silly things. You must remember his humour when growing up. I was learning to play the classical guitar and working on a piece by Sanz called Canarios (Reuben will know the piece.) Robert asked me to teach him some basic tunes and so we started with a very simple version of Canarios. He was hopeless and said when he plays it should be called to 'dance of the chicken'. When I played it he pulled a face – you know the one he used to pull – bottom lip pushed out – he sometimes called it a 'panoob' face. (God knows how you spell it!) And dance like a chicken. You might have seen some of the comic drawing of 'panoob'. Well, he never did learn to play it.

I remember the two of us working all night in the old building around the back of the Portrait Painter – which he took over as a studio (I think it's the site of Plymouth Gin now) and building a scaffold from wood and rope. I don't think it was too stable and I'm pretty sure it was never really used for any of the really big canvases. Again laughing and joking around.

You asked about The Bishop and the other vagrants – Yes, I knew the Bishop - he would often come down and sit for Robert and Robert would always slip him some money. The Bishop was always a gentleman when I saw him – although I'm told could be difficult when drunk. The Bishop would always throw the word 'Sir' into his conversations for example...
Robert or me - Hello how are you today?
Bishop – Me Sir? Very well indeed, Sir.

There was one guy known as Black Sam (sound like something from Treasure Island!!!) anyway – Black Sam always had an air of the unpredictable – like he could strike out at any time. He would come up close to you and mumble half sentences and you felt you had to guess what he was saying and respond appropriately – or else!!! His breath reeked of mentholated spirit and he would suck his teeth between phrases and his eyes would glance around like he was taking you into his confidence. There was a real sense of danger/evil being in his company, which I guess was how he got the name 'Black Sam'... He put the fear of God into some people and they would cross the road if they saw him coming – anyway I liked him. You know all about Diogenes – who lived in an old concrete pipe out by the tip at Catdown – My mother, told me that 'Eddie' as she knew him was a distant relative on my mother's side.
I remember John Kynance from Rectory Road – a very gentle soul. I can remember him coming into the kitchen once and sitting down and speaking to me in a soft almost effeminate way. 'Sometimes I like to be called Sandra' he said. I have often thought that maybe his

'problem' was related to his sexuality, not being able to be who he really wanted to be. Very sad.

Cockney Jim, Harmonic Jim they all called in and out of the shop.

Witchcraft

You will know all about your father's interest in the Occult (Witchcraft, Alchemy, Kabala,) these are some of the ideas we discussed while I was at the studio or shop

Witchcraft – Robert was friendly with Cecil Williamson who set up the Museum of Witchcraft in Boscastle, Cornwall. Cecil commissioned Robert to do a series of painting which are on display there still. After a great deal of study Robert told me he came to conclusion that the whole thing was a manifestation of misogyny – that throughout the 15th and 16th centuries the murder of thousands of women across Europe was trigged by a hatred of women by the church. That there was no evidence of any 'occult power' that could be 'tapped' into merely the paranoia of powerful men but that the development of these ideas, were historically fun to explore.

Alchemy

Many of Robert's early paintings featured elements of Alchemy. He was fascinated by the 'language' and 'symbols' which were clearly related to turning 'base people' into 'realised or perfect people'. Nothing to do with *lead* into gold. If only we could decode this language of symbols then we might be on to something. Again historically and culturally interesting.

Kabbalah

Kabbalah – As above, (I was going on to type. So below) the number of flying rabbis he painted is anyone's guess. Me at the top of the Mural. He presented a painting of Terry Goldstone and me as two 'dancing rabbis' to his mother.

The Fool

The Fool motif – You have seen the number of Clowns/Fools he painted. He recommended I read 'The Fool; His Social and Literary History by Enid Welsford. The 'Fool' has a long ambiguous history, sometimes the butt of jokes and sometimes as a wise person in disguise. The court jester which is he? The Nasreddin stories demonstrate this role and appears to be cross cultural. Robert was interested in this ambiguity.

Pierrot

There was a small theatre on the Hoe (I think it was called The Hoe) it was demolished Robert painted the entrance to the small auditorium – I was one of the sitters dressed as a pierrot. He loved the film *Les Enfants du Paradis* and the image of the pierrot in the scene where he demonstrates the pickpocket. If you don't know the film, worth a look

.

The Fool Shop

I can remember the Studio/Shop in Clifton Street – The Fool. I used to pop in for chats with your father – I think this was the time he and Annie were together. He once asked me if I would be an 'exhibit' – the idea was that he would construct a cage in the corner and I would be in it for a few days – we never discussed the practicalities of toilet use etc. Anyway it never happened. As you know Terry Goldstone lived a few doors up and many of the crowd that are on the Mural lived in the area.

Priory Road

I remember the house in Priory Road – Monica was first to live there and Robert managed to convince the owner (an old farmer) to sell it to him. He gutted that place and took it back to stone walls and bare floorboards. He wanted to 'dig' down to create a basement but the whole house became unstable so that idea was abandoned. At this time he did some paintings (mainly water colour) and Jack Shannon sold them door-to-door. I'm not sure how successful this

was but I wonder how many people might have original Lankiewicz's somewhere. I have attached this sketch Robert did of me about this time.

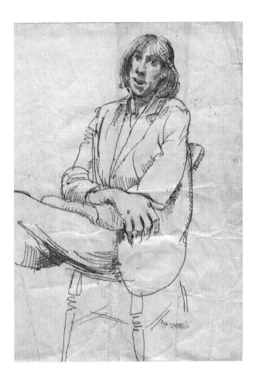

After the Fool closed your father took over a shop on the Barbican owned by Jack Nash – and called it The Portrait Painter. I spent a lot of time there. I don't know how much you know of the Idries Shah study group but there were quite a few people involved. The Vagrancy Exhibition was the start of your father's 'projects. This is one of the paintings he did of me which formed part of that project. I have this in my house.

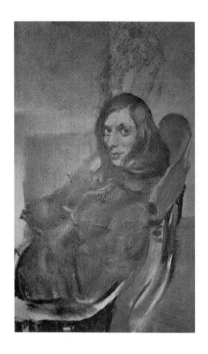

I guess you know all about the people in the Mural but if you have
any questions, I'll try to answer them. It was not long after this first
project that I left Plymouth and moved to Bath and points north.
When I visited Plymouth to see my late parents I would always try
to catch up with your father. The last time I saw him (about a year
before he died) we met at the Church where he had some of his book
collection. We drank tea and talked for about an hour - although he
was very weak and breathless, we had an interesting discussion.
Your father was a great influence on me in many ways that he will
never know.

Chapter Thirteen

Reflections

Robert was a particularly strange father. Just as I was leaving school, news got out that he had died, in reality he hadn't. It was actually a prank. Robert faked his own death! It was at this time, I had to pretend that he was really dead because no one was supposed to know the truth. I didn't even know the truth. It was an unusual situation to be in. At one point I even convinced myself that he was. No one told me much. I can't remember how I must have felt at this time but I assume I was told the truth before it became too much to deal with emotionally. This was a particularly unusual time in my life where conventional ideas of parenthood were certainly taking on a new form for me and I became very aware that this was just not the norm.

Robert faking his own death was big news at the time. It was announced on television. We were eventually made aware that he was still alive. I remember Robert leaving hints that he wasn't really dead, the main one being a clue indicating he was still alive, an exhibition sign placed outside his studio on the Barbican stating, 'Robert Lenkiewicz, Still Lives'. Other people and friends of Robert also received clues that he was still alive. I remember feeling very relieved when he emerged safely and was happily painting in his studio again. The trick was created primarily to raise some money for Age Concern a charity Robert was involved with at the time. But of course it all got hyped and a little over exaggerated in areas until it became rather out of hand. At one point I write in my diary of 1981. Reading back on all of this, I can see the impact this event had on me and many others.

I ran to Hender's Corner tonight and bought The Evening Herald. Robert should be shown quite plainly that he is dead in the papers, especially tomorrow. He was printed in the obituary column. It was awful because J called round tonight. He told us that MS phoned him up to say how sorry he was about Roberts death and that he knows I won't be coming into school tomorrow. Apparently, it was explained on Westward News tonight that Robert was dead but we missed it. J said that he felt terribly guilty lying to M one of his best friends. In fact M and everyone is annoyed with the whole situation. I'm not going into school tomorrow as I know loads of people will be coming up to me about Robert.

It was terrible tonight we were all sitting down and Mouse discovered P had left a note at our door explaining how sorry she was. We just knew that we had to tell them the truth. I ran up to P's in the pouring rain. P wasn't there but her mum was. She said how sorry she was and I had to explain that it was all a hoax. She said she had a feeling Robert would play a trick like that, especially as Mouse seemed so happy this morning when she saw her.

Mouse and I phoned Grandma. The first thing Grandma said was, "My poor darling!" And apparently all relations have been phoning Grandma tonight explaining their deepest sympathy. The whole thing is extremely serious and I hope Robert isn't imprisoned as the news is spreading like mad. One thing that happened today was I was speaking to MD. He doesn't know a thing that's going on. He told me that he passed my dad the other day. I said there wouldn't be any chance of that as he was dead. MD burst into laughter and said that he saw him on Monday morning going into his studio. My Christ I thought, Robert was meant to have died. He is also going to feel very guilty. Mouse explained to Grandma that she wasn't to believe Robert is dead. I know I am not going to school tomorrow but I'll go on Thursday. J is going to tell them at school tomorrow

not to say a word as it will upset me, really meaningful to save me the embarrassment of having to say I don't know much about it. This is only the beginning. See the news tonight.

February 4th, 1981
I stayed off school today. Partly because I have the most terrible cold and also to avoid people coming up to me about Robert. This morning there was a big announcement on Plymouth Sound about Robert and how the council were planning to do up the mural in memorial of him. It was awful as M came down this afternoon and said how sorry she was. She also offered to make our tea tonight at our house. Mouse and I had to keep it up and I felt really embarrassed lying to her. Moose said to her that if any day she found she had been let down sometime next week, please not to think nastily of us. Wolfe came home with The Evening Herald. Robert was right on the front page and it explained especially now as the reporters think it is a hoax. There was a really big article on him, a picture on him and also the painting he did of his own death which I am on holding a candle. It had printed things like a Doctor was called for and the hospital he was meant to have had the operation did not do this on weekends. P came around tonight. Her mum told her the truth about it being a hoax.

February 5th, 1981
I went into school this morning and I expected lots of my friends to ask me about Robert but they didn't. They all kept quiet about it thank god. When I went in with the prefects, MD came over to me and said, "He isn't dead Alice." "I know." I replied…
It was on the news tonight. One interview was even in the garden of Roberts house down the road and on TV. It was showing him going up to the door, saying "Alright Mr Lenkiewicz, you can come out now!" Just think, Roberts huge stone strange house. Anyway it has been certified that Robert is alive and in Plymouth now and will be going back to his studio tomorrow.

February 6th, 1981
Robert was on the TV again tonight. Apparently, when the reporters interviewed Robert, he locked them in his studio and one really shouted, saying he wouldn't bloody well be made a fool like this. Anyway, Robert has disappeared again. Anyone would think he is a madman but I know him so well...
Life living very close to my father was certainly always full of fun, madness and seriousness and many adventures! You never knew what was going to happen next.

Once, Mouse left Robert to look after me as a baby, while she went to the shops and on her return, I was screaming my head off as babies do and Robert was sitting there, calmly painting a picture of me screaming. Mouse was furious and told him he should have comforted me. Robert said that he found it fascinating to watch me get so angry and enjoyed painting me. Nothing escaped his interest!

I idealised Robert as a child. His presence was very exciting. He used to play magic tricks and conjure sweets from the air. But in the end, he wasn't your typical kind of father. He didn't want to 'bring us up'. Robert could also be very sensitive and helped me through many experiences in my life. One of those was an unexpected and vicious assault I experienced when I left London. It had a terrible impact on me. Robert was very supportive and helped me through this terrible time.

Robert could also be very awkward at times. particularly when you wanted to see him and he didn't have time or he would sometimes muddle up your plans and thoughts. This could be infuriating. He often made you question your relationships. I had boyfriends but each one was destined for the guillotine by Robert. Remembering back, I don't remember Robert really having many male friends. It seemed he preferred the company of women and he once told me

this was the case although he obviously did have some good male friends.

My mother's real name is Celia. When we were children, we would often put on music by Simon and Art Garfunkel. We enjoyed the 'Bridge Over Troubled Water' album and we used to sing "Cecilia". It was a wonderful song and Mouse would be getting ready to go out. She always looked beautiful. On a night out she would look stunning. I would watch her as she got ready. We had a very large classical arched mirror in our little council house in Lower Compton Road, Mannamead. That mirror if sped up like a film could literally tell the story of our lives there and our fashion sense and youth. So many times we all twirled our dresses and outfits in front of it.

Mouse's hair was chestnut brown and she would put on some burgundy lipstick and a line of black eyeliner over her eyes. She wore slightly hippy clothes, (mid 70s) and always a black velvet choker with a little diamanté jewel hanging from it or sometimes a little chiffon scarf tied around her neck. She looked wonderful in her denim skirt and she had amazing legs and would sometimes wear zip - up leather boots. In earlier years when she was with Robert, she wasn't too bothered what she wore. They were a couple of bohemians without a care in the world.

Robert was fond of nicknames. He nicknamed Celia, "Mouse". This was because someone once laughed at them, apparently as he burst into the room and found them in bed together and said, "What's that you have beside you, a mouse?!" I have never thought the name suited her but Robert often chose names for people that he felt suited them for various reasons. She may also have been more, shy back then and given over that impression. However, the name, 'Mouse' stuck and I can't believe the amount of times I have seen people's faces look confused when they ask Mouse her name and she replies,

"Mouse." Usually it has to be repeated twice and then finally the penny drops. Yes, this woman really is named after the little creature that eats cheese and has whiskers and a tail!

My grandmother, Doris had some paintings by my father on her wall, some still lives. I can still remember the lovely brown teapot and the blue cup on a tapestry tablecloth. Robert had given this one as a present to my grandmother. It was beautifully painted at a distorted angle and I always enjoyed looking into that painting. I get the impression; Robert was influenced by Cezanne. He had framed a leaf he had picked up from Cezanne's garden that hung in his library at the studio. Robert admired Cezanne's use of form and colour but in the painting of the teapot there was a feeling of Dutch or French still life, in the tones, colours and overall mood, inspired by the artist, Courbet or Chardin, perhaps. Robert admired Courbet and the Realism movement. He used to show me books of Courbet's paintings, particularly the still lives and his favourite painting, *The Painter's Studio*. Again, Courbet was an artist interested in painting ordinary people and ordinary lives.

I adored Robert's early paintings. There was something very gentle and almost mystical about them, particularly the portraits and the landscapes. He would paint with oils and watercolours using very soft tones and wonderful colour combinations, usually very subdued colours. He appreciated certain colours such as Naples Yellow also known as Antimony yellow and Robert always advised me to use Titanium White rather than Flake White, saying that Titanium White was warmer in shade.

When I look at photos from the past, I always find it strange that Robert, when he was younger was capable of wearing a suit and tie and he used to cut his hair very short on special occasions. I was surprised when I first saw these photos, as if a conventional dressed man couldn't exist beneath the usual bohemian image he possessed

or the image he is so often associated with but it's true. I've seen him in a bow tie and suit, his hair, short back and sides!

Robert's mother was also called Alice. Everyone called her 'Ma'. I remember visiting her when I was very young with Mouse. I have a memory of her once sitting in bed. She was not well at the time and Robert was sitting next to her gazing intently at her. I was only young but I was quite fascinated by this relationship between a son and his mother. Once, (later), Alice brought a huge suitcase of sweets for all of us children on one of her visits. I remember, she had quite a strong German accent. I was quite fascinated to watch her and Robert talk together in London. My grandmother, Alice must have worked incredibly hard when she arrived in London during the war. Whenever I think of her, I imagine the horrors of the Holocaust and the nightmare time it must have been for her in order to escape Germany.

I was later told apparently, Ayzyk Eljo, Roberts father had certainly had a very near miss with the Nazis but was always one step ahead and very lucky but also very clever. Robert used to show me many images of the holocaust when I was a child. It fascinated him and he also despised it. I often feel that his background influenced his collection of books on exploring the theme of fascism. This must have been a very difficult time for Robert's mother and father. They set up a hotel, the Hotel Shemtov in Golders Green, London and many people lived and died there, most of them Jewish refugees. I lived there with Mouse and Robert when I was a baby.

Robert used to have a room in Hotel Shemtov as a young boy. He told me about this room, number three with a green lino floor. He was obsessed with this room and this is where he used to paint, read and study astronomy. He was studying the anatomical drawings of Leonardo da Vinci, philosophy and astronomy He had a telescope he would look through towards the stars. Robert told me he loved

the view from his window where he could see the street and a red pillar box. He painted that post box many times. He told me stories of the rabbis and certain elements of his childhood in that hotel made an impression on me over the years. Robert must have been one of those child geniuses who absorbed and studied from an early age.

He was so inspired and always was. He passed his inspiration onto many of his friends and family. He inspired me and still does. It was rather like a magic drug. The inspiration connection was very strong. Robert arranged a specific time in 1977 for me to see the painting he had created of his dead mother. I remember feeling quite shocked when he showed me that painting for the first time. I was thirteen years old, the same year he painted me in his self portrait deathbed scene. I had never known of this kind of thing before. At the time, it seemed very strange to a young girl to see this subject matter, his dead mother. Robert told me he had visited her and spent time alone with her in the mortuary. He described how it was seeing his mother dead. I think he painted her out of interest and I think after everything he had been through with her during his childhood and adulthood, this was also in many ways a cathartic experience for him.

When I was very young, Robert took me and a group of children to see the film *Fiddler on the Roof*. At the time it was a huge epic with the actor, Chaim Topol playing the lead part of the Jewish father to his three daughters. The film completely fascinated me and it was as if both Robert and I were very connected through that film. It gave me some insight into Jewish tradition and values although obviously the film was a more mythological interpretation, we enjoyed it for its entertainment value, the wonderful music and the strange little violinist who played on the roof who I remember Robert was intrigued by. Robert and I sang the songs from the film for months afterwards.

Robert always loved the idea of the fiddler. I think this is where Judaism became very significant to him through mysticism and the Kabbalah and the reading of Hermetic books. He was particularly drawn to these subjects and the symbolism filled many of his paintings and ideas. I feel this interest wove into his Barbican mural. The symbolism in the mural was beautifully painted. As a young girl, I posed for it. The scaffolding had just been assembled and I remember being helped up to climb the platform where Robert was to paint me. I was seven years old. Robert painted me holding a long pole. I was the young girl carrying the banner with the tip broken off at the end. Here I am.

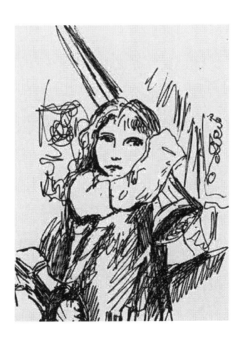

I loved that mural. Years later, Robert told me he felt the mural was not well painted but I always felt it was a great piece and such fun. Robert would show me the rhythms and lines he had established in the composition of the painting and the colours, particularly the reds that were placed in specific areas to draw focus and attention so that one's eye was drawn in harmonious relation across the entire painting. Robert was very good at this. He had learnt it from studying the great masters.

Chapter Fourteen

The Barbican Mural

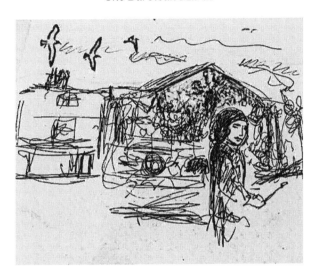

The Barbican mural was completed in 1972. Robert was so full of energy at this time and the atmosphere around the painting of the mural and the studio was equivalent to something like the sculptor Rodin. It was magnetic! People were everywhere. Robert just knew so many people and many of them were painted in this mural and were close friends of Robert and my mother, people I had grown up with. For instance there was Terry Goldstone who Robert portrayed as a knight.

Terry was a good friend of my mother, Mouse and Robert. Mouse told me he took me everywhere when I was a child. We all used to go camping as kids. Terry was quite an eccentric character with a wonderful singing voice. I remember him stoking the bonfire and singing in an operatic voice dramatically. We children lay there in

our sleeping bags looking up at the night sky, trying to get warm as he sang his song, 'Jerusalem'. The flames of the fire soared and his words, 'Bring me my bow of burning gold…Bring me my arrows of desire…' resonated amongst the night trees, the flames and the night sky. I was rather fascinated and have never forgotten it. It was very beautiful. He used to take me for long walks when I was just a toddler, carrying me on his shoulders for miles apparently.

Then there was Pat Parker who was painted in that stunning Elizabethan black and white dress. There were many other friends including us children in the mural. Robert's friend, Lemon was in the mural and recently Lemon recalled his memories to me and sent me this information on the mural and the people who were in the painting in the diagram.

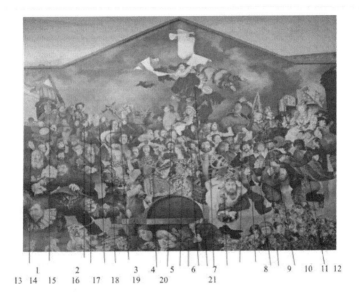

1 - Phil Sheardown

2 - Jack Nash

3. - Lemmon AKA Paul Lawrence

4 - Irish Anthony

5 - Bob Cooper

6 - Jock – Don Morrison (still a good friend)

7 - Joe Prete – He owned the café around the corner.

8. - Liverpool John

9 - Friend of Robert

10 - Pat Parker

11 - The Bishop

12.- A guy called Mike who was at Plymouth Art College.

13 - Me again.

14 - Terry Goldstone.

15.- Frisco

16 - Me.

17- Jack Shannon. Jack and I painted the base coat for the mural – Robert paying us by the hour.

18 - Alan Walters

19 - Pierre

20 - Scotty

21.- Doc

"Most of the other faces are taken from books and painting – such a Robert Flood, John Dee, Edward Kelly and, obviously, Elizabeth 1 as she didn't hang around with us lot."

Photos of the mural by Chris Kelly

Chapter Fifteen

Reflections

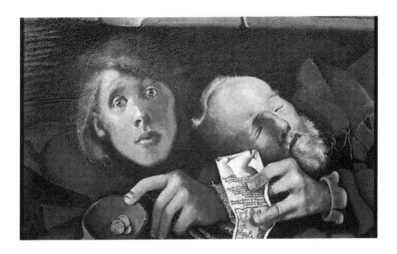

During the painting of the mural, I remember there were
beautiful women and characters and intellectuals, young, old,
academic, everyone mingling in this one corner of the Barbican.
Sometimes people would wear the costumes for their time to pose. It
was so colourful and magical. I remember the excitement that
encompassed this whole era. The atmosphere was rather like an
Elizabethan play but instead it was the seventies and something
quite haunting, because most men had long hair anyway at that time
and women did wear long dresses, so there was this feeling that the
history of the painting was emanating itself through to the present in
some way. The painting was full of fascinating Elizabethan symbols
and references.

Women were like pagan princesses and the men were like cavaliers.
It was very bohemian which was incredibly atmospheric and then on

top of all this you heard the hammering of the scaffolding and shouting and the press and people in and out and the general public becoming very excited as the image before them began to transform and develop. I remember one model after another climbing up the scaffolding to be painted by Robert and the atmosphere was intense especially for a seven -year old like me. I remember being anxious as I climbed up the scaffolding to be painted. This was Robert in his element, I feel, painting large scale public art. It was so raw but so exciting standing there and being put into this philosophical and fascinating colourful work of art.

For many years I admired this mural. I remember when it was first painted, clear and pristine, the wonderful intense blues of the sky, the clear portraits, fresh and vibrant and all the familiar people.

The day after Robert died in 2002. I walked down to the Barbican and sat on the wall opposite. It just had to be done, almost as if I would see him there. I knew I would have to. The mural was covered in pieces of wood to stop the wall from crumbling. The paint was peeling off and it was in decline. There was an eerie silence. The flowers on the studio door didn't seem real and they were sadder than sad. There were rumours about the wall being fixed and renovated but apparently there was no money. I sat there and emotion came over me and I just cried and cried.

It was as if I could still hear the laughter, voices and excitement, ghosts of the past all the people climbing the scaffolding, the smell of oil paint, Robert standing on the platform of the scaffolding, way high up enjoying himself and everyone meeting each other and having a wonderful time in this intellectual artistic pocket of time. For me, the mural was the pinnacle of Robert's period of The Fool. It represented his whole love of iconography, mysticism, colour and the idea of carnival. It was a celebration of his love of painting. I have many happy memories of it.

Later, Robert painted *The Last Judgement* Mural.

The 50ft by 40ft colour mural was made up of a series of individual marine plywood panels and a stained-glass window. This was then assembled on the side of the building, The House That Jack Built, a Craft Arcade on the Barbican next door to Roberts studio. Friends and I would meet Robert upstairs there for a coffee and to chat. I remember so many times wandering through those little shops admiring the jewellery and checking out the handmade crafts. You reached the café from a winding metal staircase. I remember there was this tropical feel about the place with a fountain and they served the most delicious cakes in the café. I will never forget Belle, who modelled for many of Robert's paintings saying, "Oh my goodness, have you tried their homemade cheesecake? It is absolutely amazing much better than the normal cheesecake!"

The Last Judgement mural on the building came along much later. In this painting, I am directly on Roberts left. I remember Robert being very proud of the swirling metal gates he had designed in red and black beneath this mural. He took me down to see the gates when they were completed. Robert could draw or design anything.

The stained-glass window was spectacular. Robert was very excited about creating the stained-glass window. The plans were laid out on crisp white paper in his studio with the beautiful saturated coloured design in progress and then finally the actual glass window waiting to be installed. It was wonderful to see it created. It really was a genius piece of work.

Robert enjoyed the vibrancy and mystic qualities of stained glass. He showed me quite a few pieces by Chagall and John Piper. He became absorbed in the detail, the colour and the whole filigree of the design. I always found it sad that the window was not lit up. I know Robert would have loved that. If only Roberts work had been more supported by the council and if they had recognised the genius

in his work, his art would have been given the attention and public space and care it deserved. Sadly there seemed to be little positive communication between him and the Plymouth council. It's sad that someone in the council didn't stand up at the time and say, "Here, here! We need to conserve the legacy of this painter in Plymouth!"

Chapter Sixteen

Growing up in Plymouth

At first it was the sixties and then it was the early seventies. I was born in 1964 and so everything up until the year 1972, is a little surreal and hazy. I think this is because we moved around so much and of course I was very young. I do know that my close bond with Robert had been established through my early childhood days and we remained close friends for many years. It was as though he was always there as part of my life. I grew up in Plymouth and he was. It was just a normal part of my life to visit him regularly and know he was there. We got on as friends for many years and I wrote and kept in touch with him even after I left Plymouth at nineteen years of age.

Memories of my early childhood up until 1972 are glimpses of a bygone era and particularly when observing the experiences of my mother who was still very young when I was a child. My early memories of those days consist mainly of experiencing her youth and the youth of her friends who were in and out of my life as a child. It was very much a time when people were creating the new so called 'hippy' culture. My mother and friends were part of the new generation of 'flower children'. The hippy culture revered harmony with nature, communal living and artistic experimentation.

My childhood was dominated by art, large hippy gatherings at Mount Edgcumbe and the houses of friends. I can remember the smell of Patchouli oil and incense, the colours and style of clothes, the sweets we ate at the time, sherbet dips, flying saucers, spangles and bonbons. Us kids played in the streets, skipping and hopscotch, juggling and hand stands against the wall was the norm.

I also remember this time through Roberts's portraits of people and then those same people visiting us. The portraits followed the people we knew or sometimes we saw the portraits and then met the people. The paintings told their stories. Everyone was of equal interest in Roberts paintings. I visited Robert at his studio and saw many of these paintings in progress, the sketches and outlines in paint, the palettes and mirrors, Robert's pots of paintbrushes. He loved to varnish his works and he adored his big black frames. Robert would be sketching his forms on the canvas with oil paint and gradually the image began to develop. I used to find it fascinating to watch him paint. It was very crisp and clean, one piece at a time would grow and stretch through the canvas until the image was fully visible.

He followed the rules of tone, shape and colour. It's very true, if you follow the rules, the image before you will appear. I have tried it and it works every time. However, you do have to practise and of course

perfect your art. It isn't enough to just learn the process. You have to dig deep down into your psyche to find that one thing that makes your work strong and to discover your own unique voice. Robert had found this. His work had depth and emotion. And of course later on, Robert had many relationships with women. This was a normal part of my life and I met many of them and quite a few became friends.

Music, I was brought up with in those early days was Joan Baez, The Rolling Stones, Bob Dylan, The Beatles, Edith Piaf and classical music. We listened to quite a a lot of sixties music in the seventies and it overlapped with the Seventies music at the time. Mouse also loved Tchaikovsky and Chopin and other classical composers. She frequently played Swan Lake. Robert particularly enjoyed listening to opera. We were all big music lovers. Early days were also dominated by adults playing guitar and a lot of smoking cigarettes. The norm of course was just smoking roll-ups. Many carried the yellow and gold packet of Golden Virginia tobacco with them along with Rizla papers. You would often try and assess a person's character by their choice of coloured Rizla papers. If they chose green colour, they were normal, if red, they were slightly different and if silver they were possibly a bit strange.

Matchboxes were also interesting with their collectible images and there were those who collected cigarette cards which I loved as a kid. There was always someone who would show you their cigarette card collection of wildflowers, or trains or footballers. You got to know people through their smoking habits and roll ups, I remember it being a talking point. Stained nicotine fingers were common and there was cigarette smoke everywhere. You could smoke on buses in pubs and cafes and even in cinemas and restaurants back then.

There were lots of pubs in the seventies before they were all made into these chain places, each of them had individual character, some

with beautiful architecture and historical features and were a focal point of the community. They were fun. That's where you caught up with people. We all dressed up to go to the pub. You knew you could meet certain people and friends in each one. The Dolphin, The Minerva, The Kings Head, The Wellington, The Unity were my frequent haunts.

Cannabis was also smoked often. Reflecting back, there was a lot of drugs going on in Plymouth at the time. Some people casually smoked cannabis and there were many who were also addicted to class A drugs. There was a lot of it around. For a few years it surrounded us socially and sometimes you would hear of someone who had tragically passed away as a result.

We children got older and the city drug scene seemed to become more prominent, especially in the early eighties. Robert was concerned with this idea of addiction. He spent many years in discussion and painting subjects on this theme. He would say to me, "We all have an addiction. For instance, some people are addicted to drugs just as I am addicted to books." Robert, of course was extremely against drugs and alcohol. He didn't drink or smoke and he was always warning me and others of the dangers of alcoholism and smoking. As a young girl it was good to have this advice. Even though I was a teenager being wild, his advice kept my head above water. Other than the usual teen extremities of drinking and casual smoking of tobacco and cannabis, I managed to keep check on myself and I never got too dragged into that world. I met people at the time who had addictions. My boyfriend would take me visiting his friends around the city. It was quite common to turn up and find people hallucinating, injecting heroin, smoking drugs, eating drugs or doing amphetamines. It was a reality around me in my youth.

In my later teens, I had this passion to create art inside me but I had not had the chance to express myself in that way properly. Watching

Robert paint throughout my life inevitably led to a longing to be creative. However, expressing yourself as a female artist in the early eighties was challenging to say the least. I always found it odd that more women were not painting. There was at times some snobbery around education and what one was expected to do with their life. Egos and elitism did get a bit much sometimes during that era. I eventually moved to London with a boyfriend at the time. As difficult as it was being eighteen years of age in the middle of London with no proper career in place or security, I survived and it taught me about life. I always kept in touch with Robert when I moved away from Plymouth and visited him often and Robert often encouraged me to pursue my art and create.

My early childhood in Plymouth contained good and bad times but also, we were very poor. Mouse really struggled financially in those early days. Money was always difficult back then. I will never forget people asking us if we had 'two quid' or 'a sixpence' or "five Bob". Sometimes we literally had nothing to eat except some onions and flour in the cupboard. There was a communal approach to life for a while, families living and growing up together. There were difficulties and lack of facilities. There was a lot of moving about to different flats and houses.

Things got bad at times. We were borrowing change for the electric meter and sometimes there was no food to eat and we would live off jam butties and margarine and sugar sandwiches for a few days at a time until things improved. In general, there were a lot of broke people around. Everyone seemed to be borrowing money back then. We were all on the dole which was in many ways the norm at the time. People who had proper jobs were strange, like off another planet. Many people on the dole were artists and poets. It took some years for me to ever contemplate people who were in a so called 'proper job' or 'career minded', as being normal. In many ways, artists were just too busy creating to bother with jobs. If free money

was offered then why waste one's time working in a job they hated when they could be writing a novel, painting or travelling the world. There were of course those who wanted a 'normal job' and were unemployed and 'actively seeking work' but I never met any.

Robert was of course his own boss. He got by day to day. He never really spoke about money to me. He just survived but I don't think he ever had any money managing skills. If he sold a painting, it would sometimes pay for an antiquarian book! When it came to finances. I don't think he really had a clue but if he had money, he was happy to give it away. It was more romantic back then. People had this Dick Whittington approach to life. They would just pack up and travel or move away or join a commune, call themselves artists and writers and live the life and be artists in attics for real, anti-establishment yes but during that time I saw the passion and struggle of art through my father and other friends, none of it attached to any formal or institutionalised praise or qualifications.

Many of us believed in sailing the ocean on our own terms. I never thought the way that an artist was perceived or canonised bothered Robert but I do remember once in his studio, him being rather perturbed about some news and saying something about how things were changing in the art world and apparently artists were not considered proper artists unless they pertained to certain 'requirements' but never the less "artists can still be artists" he said seriously and with an air of confidence that completely threw this new concept he had heard out the window.

After Mouse lived in Rectory Road, helping Robert look after the homeless she eventually moved with me and Wolfe to many other abodes such as Turnchapel, Keppel Terrace, Clifton Street, Wolsdon Street. Becky, my sister was also born during this time. Her father, Jim lived with us, on and off for many years. Jim was a full-time writer. Then we kept moving, and we lived in Saltash for a while

and then we went to live in Robert's house in Priory Road for a short time, as we had no place to live and then, finally we moved to Stoke in Havelock Terrace. For at least four years we were on the move. I remember it being a confusing and unsettled time.

Once we landed in Stoke, our routine seemed to settle down. In that same year, 1972, Robert had worked on the Barbican mural and had painted me in it. I was seven years old.

There was a shift in our routine and lifestyle when we moved to Stoke in Plymouth. There was hardship but also a sense of stability finally came upon us. We had some happy times there. I remember being given my first pair of roller-skates. David Cassidy and The Osmonds were all the rage. Jimmy Osmond's song, 'Long haired lover from Liverpool' made it to number one in the charts. Us kids were all singing along with it. Denim and Levi's, yellow smiley faces and Coca Cola were iconic brands. It was the early seventies.

We played in the street with our friends. We used to play on the cliffs by the railway lines, play hide and seek in the debris of the old bomb sites with Jim our stepdad, bicycle ride if we were lucky enough to have a Chopper, the popular bike of the time. Ice cream vans and fish and chips in newspaper and a trip across the ferry or to the cinema, were our main treats. We used to go to The Belgrave on Mutley Plain, the ABC or Drake Cinema. I saw the musical, *Tommy* for the first time with my stepfather, Jim at The Belgrave cinema. Many dads worked down the dockyard and the sons would usually say they were following in their footsteps.

Mouse sent me and Becky to knitting and piano lessons with Mrs Taylor in Stoke. I still remember Mrs Taylor sitting there wearing those nineteen fifties style glasses, eating her blancmange while she taught me to play 'chopsticks' on the piano. We did also learn to

knit a pair of mittens. I remember mine were pink and Becky's were blue. We had used a pearl stitch and we were very proud of them.

I used to play in Devonport Park, Stoke. We had lovely summers there with picnics and making daisy chains, sitting on the grass sipping cherry and lime aid. We used to play on the huge iron cannon. I would roller-skate down our street and over the bridge at Havelock terrace and Mouse would always shout at me to stop as I dangerously sped down the hill like Beryl the Peril.

We used to love the Torpoint Ferry and visiting our grandparents, Doris and Eric in Cornwall. We would catch a train from Devonport station to Liskeard. The trains had those little carriages back then with windows and curtains and the connection on the floor of the train would move backwards and forwards like a giant elastic band so you could see where the train divided. It had that timeless atmosphere of The Railway Children. The journeys to Liskeard were exciting. I looked forward to them. We would have breakfast at Aggie Weston's Café at the bottom of Albert Road in Stoke before we boarded the ferry. Our grandparents would meet us at Torpoint and drive us over the Tamar Bridge. I used to love that journey and looking at the bridges and the subsequent one built by Brunel and the giant viaduct on the way to Liskeard always intrigued me. Once in Cornwall, we would stay at our grandmother's farm, 'Polmartin'.

Polmartin was just heavenly, flowers everywhere, particularly, primroses, foxgloves, hydrangeas and carnations and there were fords, meadows and streams. It was like living inside the book, *Wind in the Willows*. I loved it there. We used to go for long walks with Mouse in the deep countryside, over to where they used to film the *Poldark* series, one of our favourite programmes. We would explore for hours, then return to our Grandma who was making hot bread rolls and wonderful dinners. She would make home made coconut ice, fudge, toffee, chocolate and fruit cake, home-made bread, hot

from the aga, home-made ice cream, home-made blackberry jam, home grown cooked vegetables.

Everything was cooked from scratch; she was an incredible cook. The ticking of our grandfather's beautiful, handmade pendulum clocks would chime and echo in the cool slate quiet rooms. The hydrangeas and pink chrysanthemums would be arranged gracefully in vases around the house. Sometimes we would practise the piano. I remember it was a lovely cream coloured C. Bechstein with a beautiful tone. Many inspired hours we all spent practising tunes and songs at that piano. My grandmother and Mouse would sometimes break into a nice piece. My grandfather Eric's workshop was filled with his microscope and tools. There were framed sepia photos of him and Doris in their youth, during the Second World War showing them on beaches and dressed in classical nineteen thirties clothes. (I loved the nineteen thirties fashion.) They would take us on outings to Looe and Polperro, St Ives, and many more Cornish towns when we were children. They were fun days. I used to soak up the scenery and the little shops. I remember, I always bought a little bottle of green violet perfume with the pixie on top. I loved the smell and the green glass bottle.

There was another story in my grandparents' house, a story of finding love in the Second World War and Mouse growing up as a child in Dropmore, Maidenhead with her parents. Stories of the war from my grandparents used to fascinate me. They used to talk about the bomb shelters and the rations and the harsh living conditions. They worked their way up from poverty to very wealthy. They worked extremely hard in an era where there was no such thing as any support. You just had to survive and that was it. They were tough people. They had learned the hard way and now they lived in comfort. They seemed to have that ambition for financial success in their blood. My grandmother became a teacher and Eric a talented

engineer. He was always making and inventing things. I have fond memories of those Cornish summer holidays.

We would return from the big country farmhouse to our flat in Havelock Terrace, Stoke, our little modest abode at the top of the house. We rented our flat from Mike Brown, known as Mr Bee an iconic person of my childhood. He had a shop and café in Plymouth called 'Mr Bee's Fun Factory'. He was a big man with flared jeans, long hair, waistcoat and patterned seventies shirts. I will never forget him and he had a warm big laugh. Sometimes we visited him in his café at Drake Circus in Plymouth and he would serve us Coca Cola from his cola machine where the oranges used to swirl around inside. I don't think Cola was ever as good as Mike Bee's cola. We rented Mike's upstairs flat and we were quite happy there even though it was small but eventually Mouse got offered a Council house in Mannamead in Lower Compton Road.

Mouse was so happy when she was offered that flat. I remember her buying a bottle of wine and flowers for the council officer and then telling me his face went beetroot red with surprise and happiness for her when she gave him a big hug. I remember feeling excited at the thought of moving to our first proper home.

Sometime around 1975, we moved to Lower Compton Road in Mannamead. I was coming up to eleven years old. Our new council house was in quite a posh area. It was a strange set up but we were happy there for many years and spent our childhood and teen years in this home. Robert's house was only a five-minute walk away, in Priory Road which linked to our road. I always remember visiting Roberts house there, covered in ivy and the garden full of wild-flowers and weeds. Even back then, the house held memories for me as we had lived there for a time previously. I remember the garden had many caterpillars, yellow and black stripes. Us children would get covered in them. There were some stone steps that went quite

111

high up around the back of the house and we played around there quite often.

I was only young. In 1975 and I wore polo neck jumpers and pop socks were all the rage, wedge and platform shoes. Mouse used to buy me clothes from C&A. and then in my later teens, age fourteen to sixteen, about 1978 to 1980, I enjoyed the later disco look; I used to wear split skirts and leggings with heels and the ballet cardigans were popular. The band Blonde was all the rage. How many times I must have played and danced to her songs, 'Heart of Glass' engraved into my youth.

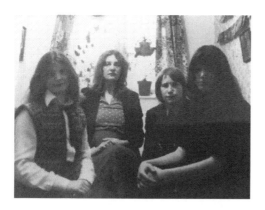

We used hairspray and lip gloss and highlighter on our cheeks. Make-up and fashion for teen girls was so different at that time. It was the 'Hot Gossip' look, glitter and pearly eyeshadow's, eyebrows were plucked thin and we were all very slim. Diets back then consisted of fasting for a few days, then fruit and natural yogurt for a day and that kind of thing, we hardly ate and takeaway culture had not properly come in. We were like sticks and thought we were obese when we went slightly over a size twelve. It was also the era of the film *Grease* and the film was huge! It impacted most of our early teens. I remember Mouse and I singing 'Hopelessly Devoted

to You' and 'You're the one that I want', many times in Lower Compton Road. I remember standing outside the cinema in Plymouth in a huge long queue waiting to get in to see the film with my school friends. Fashion became very influenced by this film at the time.

Robert sometimes gave me £20 which was a lot of money back then. He would say "Go and buy yourself a nice dress.'' I would take the bus into Plymouth City Centre and buy clothes from Top Shop and Miss Selfridge. There were some days at school when I would skive off and make my way to town for a cup of tea in Dingles, visit a friend or wander around The Barbican and go and visit Robert.

I had friends at school and was fond of the people there but there were times when I felt out of place in my early years there and very shy. I wasn't as confidant as some of the other girls. They helped me gain confidence in many ways throughout the years. I watched with interest the way they applied fashion and make-up, the way they flirted and talked about boys, their slimming fads, hairstyles, fashion and music. It was interesting. The singer, Donna Summer was popular and punk music was also in. I started to become aware of boys and I gained attention. I rarely had the confidence to talk to boys. But after five years of being at my school, I soon went from a quiet girl to quite a rebellious street wise, confidant sixteen-year old. I drank and smoked and went out until early hours.

My late teens in Plymouth were basically, parties, dancing, drinking and kissing. I remember once, I had drunk so much with a friend, 'Steve' that I had to lay on the pavement. It was on North Hill. I was looking up at the sky and everything was spinning around me while Steve took care of me. Dear Steve, he was a lovely guy. Suddenly a taxi stopped and a man stepped outside the car. It was my father, Robert. He walked over towards us and asked Steve politely if I was alright. ''I think so.'' he replied with an uncertain tone in his voice. I

saw Robert's face peering at me seriously, looming above me, his head against the night sky a bit like Moses, hair blowing in the wind. He then seriously and calmly stepped away and went back in the taxi and drove off. I can honestly say that was quite a turning point for me. Somewhere in my subconscious it changed me and I never looked at alcohol in the same way again.

Back in the seventies, we socialised more at an early age. There were no mobile phones and TV was still a luxury. There was no internet and you were considered posh if you had a home phone and a colour TV. We had radios and vinyl for music and having a tape recorder or a typewriter seemed like high technology. I had a little record player on my bedroom floor. That's where I listened to all the singers and bands of the time. We didn't have internet. We had big speakers and music. People were into quality speakers for their sound systems. I remember once I was given some speakers that were enormous and like large cabinets. The sound that resonated from them was beautiful, like nothing I have ever heard since.

We made our own entertainment, hung out at people's houses and partied, cooked meals, went for long walks. I remember my boyfriend and I driving through the countryside at night with Iggy Pop and Kraftwerk blaring out of our open top car. I cherished the Devon and Cornish countryside. It was spiritual. There were many times when I lay in the forests next to streams on my own, tuning into the magical essence of nature and becoming aware of spirituality. The countryside around me was inspiring and highly valued. There were never ending things to do in Devon as there were so many beautiful beaches and so much countryside back then. Friends just knocked at your door when they wanted to see you. If you arranged to meet someone and if they didn't turn up after twenty minutes of waiting, it was custom to leave. Life was easy to organise.

We socialised, danced and dated at quite a young age. At fourteen and fifteen I was out clubbing around Plymouth. It was through the disco era and into the late punk era. I remember going to clubs on Union Street, Castaways and Ronnie's and The Sea Angling Club on The Barbican, dancing to songs such as 'I will survive' and songs by The Bee Gees and ABBA. We all waited for the smooch song. When the band 10CC sang 'I'm not in love', we were so happy when we were asked to dance.

I used to go into Virgin Records in Plymouth and also Woolworths to buy my singles and albums. I loved Blondie, The Pretenders, Bruce Springsteen, Rod Stewart, Iggy Pop, David Bowie, The Beatles and Fleetwood Mac. But I also listened to earlier musicians like Bob Dylan, Joan Baez and The Rolling Stones. Sometimes we would go out and watch live bands play. The room would be packed, full of people pushing and drinking and you were lucky to come out in one piece. Music back then took up much of our social life. My teens could be summed up with the music from the seventies. I have a memory for almost every song and where we could have been at the time. At the end of the day a quiet afternoon in nineteen seventies Plymouth was sitting in the sunshine, Mouse doing a crossword and me reading a Jackie comic while in the background, you would hear the songs 'Davy's on the road again' and 'Forever in Blue jeans'.

We spent much of our youth on beaches and enjoying the long hot summers of Cornwall. I have fond memories of those days. We used to take the bus to Whitsand Bay for our summer picnics. Our cheese and cucumber sandwiches made from white bread slices would get dusted in sand. We would dare to swim in the cold sea waves and explore the rocks and pools as children. It was a happy time. In the mid- seventies. I used to swim in the outdoor swimming pools, during the hot summers on Plymouth Hoe.

The outdoor pools were packed, everyone sunbathing on the concrete steps. We would take the boat over for picnics to Mount Edgecumbe and Calstock and my friend had a boyfriend who worked at Drakes Island.

At one point, we enjoyed the Andy Howard Freak Shows at Abby Hall in Plymouth. I remember so many times head banging to heavy rock music at those events, so young and innocent we were. It was so important to us back then. Andy Howard put on great events for us youngsters at that time.

Sometimes, I would sit on the wall opposite the mural on The Barbican. Robert would come out of his studio door wearing a brightly coloured stripy scarf. He had a thing about scarves. It was what me and my brother, Wolfe called his ''Dr Who phase''. Robert was looking quite a bit like Tom Baker from the 1970s series. Wolfe and I loved Tom Baker and we always laughed because he reminded us of Robert.

This was also a time when Robert wasn't particularly looking after himself very well, health wise. In many ways, Robert led a rough life. He didn't always have that normal home routine where he could cook proper meals and he was conveniently eating junk food. I remember being rather concerned about it. He didn't seem very bothered or aware of these things. Robert also asked me to make him a scarf, so I did. I remember it was bright and woolly and he wore it until it fell to bits. He also asked me to make him some patchwork cushion covers. He wanted them to be a mixture of all different blues so I sewed one at school as part of a project in my sewing class. I had spent a long time making a patchwork of squares out of different shades of blue cotton fabric. I was so proud when I presented it to him.

Robert also had a thing about shawls. He loved all kinds, exotic ones, plain ones, and gypsy ones. I remember once on my birthday; It may have been my fourteenth birthday, Robert turned up at our house in Lower Compton. He was with a Columbian lady with long dark hair. I'll never forget Miriam. She was very exotic and beautiful looking. She also had double jointed fingers that fascinated me and she once showed me how she could bend them all the way back to her wrists. Her fingers had long crimson nails. She quite often painted them while looking after Roberts exhibitions. She wore ponchos and long dresses. It was a way of dress I couldn't quite relate to at that time. I was just a little too young. Most of Roberts girlfriends had their own style and it was quite hippy at first. I remember them wearing long maxi dresses and cloaks and the long hair and they wore very individual lovely clothes. It was very inspiring. I remember Robert being very conscious of beauty. He was fascinated by it and you would do what you could to impress his connoisseur eye. I remember once saying to him, I was fed up with my hair and asked him what I should do and he replied, "Do what you want with it, just DON'T cut it!"

Robert gave me a present for my birthday. It was a Columbian lilac shawl made out of a very heavy fabric with long lilac tassels along the trim. I remember loving it but I just couldn't imagine myself ever wearing it and so I used it as a cover for my so called 'dressing table' at the time. Looking back, it was a beautiful shawl, top quality. I would love a gift like that now. The shawl remained with me for many years, until it became old and worn out. It was a very beautiful colour, lilac and was a gift made for a princess. Thank you, for thinking of me on that day, Robert. X

We also met up with Johnny, Roberts's brother sometimes and once I met Bernard his twin brother. I remember I visited London with Robert a few times as a teenager. We used to walk down Portobello road. It was full of amazing stalls and shops. I loved the jewellery at

the time. I remember the Body Shop was in its early days and you could get refills on your shampoo if you brought back your container. The labels on the bottles were handwritten by the assistant at the time. There was much Rastafari and reggae music playing while we were there. I loved Portobello Road. I also met Robert's friend, Aury who was sweet and took us for coffee and lunch in a café in Portobello. His house in Westbourne Park fascinated me with all its bohemian décor and floor cushions, velvets and beautiful colours. He and Myrna made amazing clothes. They had all studied at St Martin's together. Looking back it is strange to think that visit wasn't too long after they had all been students together at St Martins, possibly about fifteen years later. Robert chose some of Aury's clothes to take with him. They were vivid colours, like jewels, velvets mixed with crochet. I remember Aury liked to tell stories and fairy tales. I have fond memories of visiting him in London. He was always very generous.

On one journey on the train from London back to Plymouth with Robert and Mary, I remember watching Robert paint Mary in watercolours. Mary was staying in a flat in Notting Hill. It was a beautiful, airy flat with a roof balcony. They were those huge tall white houses, just off Portobello road. There was a feeling of community amongst them. At the time they were a little run down. They are worth a fortune now. Mary was around quite a bit and I got to know her a little. She was very sweet. We both went to Elephant Fair at the Port Eliot Estate when the giant festival was there. I loved Elephant Fair. It was a yearly event organised by Perigrine, Roberts close friend and patron. Robert introduced me to Perigrine Elliot, the Earl of St Germans for the first time on The Barbican at his studio. It was one summer afternoon. Perigrine had come to visit Robert and I asked Robert who he was. Robert said he's a Lord. I expected a man with a suit and a top hat to emerge from a limousine but instead Perigrine turned up on a motorbike, wearing torn jeans with

a leather biker jacket. It was my first experience of meeting someone who was very affluent who didn't show it.

Later, I visited the house in Port Elliot and Robert showed me around, including his huge riddle mural in the round room that he was working on at the time. I recall Robert saying how he wanted a glass floor and to paint a mural beneath the floor with people descending into hell. He was keen on the idea of making this floor a very durable glass or Perspex and underneath there would be this pit of red flames and people falling. It was a fascinating idea.

In my late teens, I was in the clubs in 1979 when the song 'My Way' by Sid Vicious was released and then he died. There was doom and gloom in the atmosphere. All the punks were mourning his loss. It was the end of an era. We all felt it quite strongly when Sid Vicious died; it had been a huge shock for us all when Elvis died in 1977 and then when John Lennon died in 1980 it was as if the world we had once known had turned on its head. John Lennon's song, 'Woman' was number one for a long time and sums up my late teens in Plymouth and then suddenly this new wave of music came in called The New Romantics and they hit Plymouth with suits, ties and black eye make-up. There was this new band called The Human League. The women had short hair! Shocking! We had been through so much already and we were still only sixteen. It was a new era. I felt happy and I was ready for life and thank goodness it was my last day at school. It was 1981, I was free at last!

It wasn't until I left school that I suddenly got an eye for vintage clothes and developed my own style. I loved the black eighties, vintage, Victorian glam look and bought and collected many nineteen thirties dresses and coats that I cherished and wore for many years. I used to go shopping in the Plymouth antique market's, charity shops and Upstairs Downstairs near North Hill. Many of us used henna on our hair at this time and I had it that colour for many

years. We used to drink in the Minerva pub, The Kings Head and The Dolphin pub on the Barbican.

During the days we would venture up to Plymouth Arts Centre that served vegetarian and vegan food before it was ever a big thing! I went from disco to pencil skirts and batwing tops. Electric blue was the fashion colour of the early eighties and then there was this kind of garage retro, girl band 'Bananarama' dungaree and headscarf look that came in. This is when I started to mix old and new, abandoning my mainstream style and suddenly I went for a more alternative combination of punk, vintage classic style clothes and fashion seemed a lot more important back then. We went to town with the make-up and hair!

During this time, I would sometimes meet up with Robert and he would take me out for a meal, usually to The Piermasters or The Wine Lodge on The Barbican. I would arrive at his studio. His diary would be open and I could see he had written his latest notes. Mary

used to wander in quite frequently and help with the exhibitions. She was a gentle lady. Robert was infatuated with her at the time. Mary had a lovely laugh and she was very pretty. She used to put a dot of vivid blue eye shadow in the corner of her eyes nearest to her nose which was quite unusual.

The whole restaurant would go quiet when Robert entered the room. It was like being with royalty. Everyone turned and looked..Those were fun days when we didn't have to make an appointment with Robert. We would just show up at the studio and go for a cup of coffee and a chat and a meal. He always took time out to talk to me and spend time together. Later on, when his 'appointment book' came in. I remember my family all looking at each other in horror and disbelief. We would have to make an appointment to see our own father? Eventually, we accepted it. Looking back it must have got busier for Robert and he was just genuinely unable to give up his time on an ad hoc basis. And even when we made the appointment and met him, someone would always turn up unexpectedly. That was a system that eventually broke up that natural flow that many of us had with Robert, what used to be just relaxed and spontaneous meetings. Suddenly we were on schedule. Robert's life was becoming more intense as he built up relationships with people and regular exhibitions were being researched and worked upon.

A big chunk of Robert's dream was his library. He was acquiring a large number of books at this time and he was beginning to acquire the books he wanted for his collection. These then went into his new library. I always remember the start of the building of his library at the studio. There was all this commotion and building work going on. Dave the builder was around frequently. He was a good friend of Robert. Robert was describing how it was going to be with a red carpet and wooden stairs and wooden doors. He was excited about it. He even had the Emily Dickinson glass bookcase placed in his studio. Robert was also acquiring a number of book presses and

bookbinding equipment. I think he had visions of a book bindery at the top of the studio and he had started gathering together the pressed and antique type cases which always fascinated him. He gave me one of those book presses for the work I eventually carried out for him and a friend gave me a lot of old type cases that were no longer needed from a local printers.

The book press Robert gave me was a funny old thing. This was a solid cast iron Victorian book press. Very strangely, one iron handle had somehow been 'snapped' off which was a huge mystery and goodness knows how. It took two people to lift it. I had it for many years and moved it with me from flat to flat. I used it for all binding on Robert's books as well as my own projects. It was wonderful. An hour of the book press and the item would come out smoothly condensed and perfectly flattened. Sadly, years later, I had to abandon that dear thing and I reluctantly left it behind in the cupboard of one of the houses I rented in Oxford when my children were born. I was about to move again up north and for one reason or another, I just could not take it with me anymore as it weighed so much. It was that heavy, the boot of the car would fall lower. I remember feeling very sad doing this, as if I was leaving an old friend behind which I was. However, being caught up with motherhood and crying babies at the time and a new life in the north awaiting me, it must have been a relief to let it go.

Robert was very fond of music. One of his favourite singers was Catherine Ferrier and he would often play some music by her when I came to see him. I loved his studio. It was so big and dark and old. Inside, he had acquired a large antique four poster bed which he used in many of his paintings. It really was so exotic and made part of the studio very plush and renaissance looking. Robert liked his turps to clean his brushes. He had jars of it and his brushes were always ready for painting. He was quite ordered and organised in a disorganized way. His pallet was beautiful. I loved those palettes

containing giant blobs of white, crimson and yellow ochre. So many times I saw him prepare them with his giant tubes of oil paint.

Robert had a story that some people know concerning his theory about colour. It related back to his time with a Jewish rabbi who lived at hotel Shemtov. Robert was looking at the grass saying he loved the colour green but the rabbi said it wasn't green and Robert was surprised and didn't understand. He was only a boy. "Look harder", said the rabbi, "look harder and really see it." So Robert tried harder and said well I can see a bit of blue "Yes said the Rabbi, look harder still, what else do you see?'' Robert replied, ''Well I can see a little yellow and white and some darker green and a little blue actually,'' and so it went on until the rabbi said, "you see, it isn't just the colour green. The grass is made up of many colours." This was Robert's first lesson in colour theory and he passed this on to me in later years by telling me the story and giving me books to read about colour by Joseph Itten. Robert later showed me a book called; *Yellow and Blue Don't make Green*. This had a profound influence on me but the book that I loved more than anything was Kandinsky's *Concerning the Spiritual in Art*. Robert gave it to me and it revolutionised my whole approach to painting.
Robert was very knowledgeable on colour and one day when he was giving me an art lesson in colour and tone, he quickly created this colour board for me. I still have it to this day.

Tonal board by Robert

Our life in Lower Compton Road in Mannamead was a life of the mid-seventies to early eighties. It was a modest and poor little council house but we were happy. We were surrounded by friendly neighbours and made friends with most of them. Our days were full of people calling round, picnics in Thorn Park and walking down the long hill in Mannamead to Mutley Plain to meet friends and onwards to go out. We had an amazing social life. Our little council house, I feel was a bohemian hub for every person we met during that fascinating era. I lived in Compton until I finished school at 16 years of age. After school I went on to the CFE for a brief spell and then to Plymouth Art College to do my foundation in Art. The annexe was based on Union Street. I used to walk along to college and sometimes I would pop in to chat to Doc, an antiques dealer and one of Robert's friends and models. I was happy at the college and made some lovely friends. It was my late teens and the beginning of my independence. At the college, photography was my main passion at that time. John Hill was our photography teacher. He taught us to use the dark room and basically everything about developing

photographs from scratch with the use of traditional Pentax cameras before digital was even heard of.

John Hill was tall and thin and was basically a punk with his white jacket and black spiked hair and black skinny jeans and doc martins. He used to wear a safety pin through his ear. He was definitely one of Plymouth's avant-garde outsiders and I got to know him a little. I will never forget in one of our art sessions he had a model and friend, Louise who was laid stretched out on a bed dressed as an Egyptian mummy. She was covered in white powder and her eyes and face made up in a post punk mummified way, her hands crossed upon her breast, her eyes closed with the room low lit and John put on this experimental music. Very slowly she came alive on the bed and then carried out a dramatic and contorted breathing performance art with her diaphragm flexing up and down. It was wonderful and challenged all of us so called 'conventional' young students who looked at each other in a state of puzzled awe.

On one occasion John invited me to his flat and we got so drunk that he managed to persuade me to pose naked inside a cage where he took photographs of me. They were wild times. Robert and John never quite saw eye to eye and I remember Robert once telling me that John had come into his studio and apparently Robert had questioned him on this, asking him what he was doing there seeing as he had never shown any interest in popping in to see him over the years. I think something else must have happened between them. Apparently, they spoke in Robert's studio that day when John popped in and they had words. I don't think they ever communicated again after that.

Many of my days back then were divided between visiting Robert, my friends and going to see Jim, Becky's dad at his flat on North Hill. Jim was an intellectual and a writer. He played us records of old musicals, *Pennies from Heaven* and *Cabaret* and we watched

Hammer Horror movies with Peter Cushing and Boris Karloff, watched cult and art films such as *The Clockwork Orange* and *Les Enfants du Paradis,* talked about books and art and culture. Jim was obsessed with Sherlock Holmes and taught us about writers, films and actors. We became literary and knowledgeable of popular culture with Jim as our tutor. Jim wrote and typed practically every day. He was the eternal romantic and the 'artist in the attic'. He used to recite his works back to Mouse at our house in Compton and await Mouse's feedback, a regular occurrence. Jim was a huge part of our lives at the time and close friend of Robert for many years.

The years flew by. It was a series of adventures with friends, family and happy times. Christmas was full of sparkle and joy like something out of a Dickens novel. In the afternoon we would go down to The Barbican for the Plymouth Bus station Christmas meal for the homeless that Robert had organised. There would be quite a few people there, relatives and friends all mixing in with the homeless. Sometimes you wouldn't know everyone's names. It didn't matter. We would all be standing and sitting on the benches and the walls eating our food and chatting. It could get quite cold sometimes. We wrapped up warm. There were usually some photographs of us all and Robert would be there serving up the hot food donated by the local restaurants and cafes. We took it for granted really. It all seemed very normal. Robert was always in his element and enjoyed the day.

The Bus station meal was a yearly event and Robert liked us all to be there. I went most years but as I approached my late teens I remember going off with a boyfriend for Christmas to his parents' house and Robert wasn't too happy about me missing it so I had to try and visit the bus station Christmas meal also. It could become quite hectic at times with our Christmas agendas. We all walked to each other's houses to say hello to family. We would start at home, then the bus station, then walk to Monica's where she would be

putting on a huge lovely meal for everyone. They were fun days and the whole family would catch up properly during that time. Robert was very much pulling the strings on how we all socialised with each other. He was always telling me to go and call on people and say hello which I did.

I lived in that house in Lower Compton for many years and then one day Mouse moved to a big house in Yelverton. Life was different there. Suddenly, for the first time in our lives we were living in a house on a mortgage with lots of rooms. I actually had my own big bedroom all to myself. I loved it and remember gathering wildflowers to display and I had a proper dressing table! I started working at the Royal Oak Pub in Meavy, part time as a barmaid and I loved it there. The owners, Des and John were wonderful and taught me a great deal about serving drinks and food, dealing with money and customers.

In 1981, I had left school and I was living for a while in Lower Compton Road before we all moved to Yelverton. I remember being given a diary for my birthday in and Robert visited me that day and watched me write in my diary curiously. 1981 was a significant year for me. I began to write in that diary and every day of that year up until 1982. I wrote about my life in Plymouth. I still have that diary today!

I left home at seventeen years of age to move in with a boyfriend to Plymstock. Mouse always said, she shouldn't have let me go as it was too young but I learnt a lot about life.

At eighteen I had moved to London. I didn't see Robert as much then but we always stayed in touch. Throughout the eighties, I visited Robert during this time to pose for some of his paintings. I modelled for his education project. I was the girl on the cross in his triptych. I modelled for his Last Judgement mural on The House that

Jack Built and for various other paintings. It was a time when Robert and I chatted about many things. For twenty years, after I left Plymouth we kept in touch and I met up with Robert each time I returned to Plymouth. I missed him a great deal. By the age of nineteen, I was living independently in my own flat in Sussex and had begun my own adult life and that's a completely different story.

Chapter Seventeen

The Studio

Robert's studio on the Barbican will never be forgotten. It was a vast warehouse loft that he turned into an artistic space of mythological dreams. It was stunning. It was quite dark as Robert enjoyed low lighting. Sometimes a candle would be flickering. The canvases were everywhere, piled in stacks and hung up against the walls. You rarely saw any wall space. The colours of the studio were rich, ruby reds and emerald greens, sapphire blues all depending on what Robert was working on at the time. I used to love watching him paint fabric. There was an interesting sense of space, as if you could walk on forever. It was divided into two parts and there were some unexpected corners and nooks that were sometimes a little disorientating. On the far side blocked off by paintings and a partition was Roberts studio bedroom with the beautiful antique bed Robert had acquired. Again, this room was also stacked with paintings and some beautiful antique objects. When you looked over the main studio you would see Robert's

easel. He quite often had a mirror assembled next to the easel. His brushes and palettes would be prepared for work and there was usually a painting in progress or a clean white canvas waiting to be worked upon. The studio was beautiful. There was another room to its left before you actually reached the studio and this is where Robert would keep some of his specialised books such as The Emily Dickinson Collection and specialised objects and books from his collection.

The amount of paintings and projects I saw Robert work on within the studio was phenomenal. I saw him paint all his major projects here from early works on vagrancy all the way through to the 'blind-tobit-paintings' It is emotional to see many of these paintings and remembering back to those moments in the studio, watching Robert while he painted them or displayed his works at the time. As well as the studio being Roberts artistic space, you always met new people there. Robert had an incredibly full and interesting life. People from all walks of life wandered through the studio and arrived with appointments. It never ended although sometimes there were quiet times, usually late at night

Sometimes on the Barbican, on my way home I would see the light on in Robert's studio and would go and say goodnight. I would knock on the studio door, walk inside and up the stairs. There would be silence and possibly I could hear his footsteps. Robert would be up there somewhere. Suddenly he would appear. He would show me a painting he had been working on throughout the day. The stories were varied about the paintings but depending on the project he was working with, they could also be very tragic. Robert grew to know so many people and because of the project themes he also educated himself about many subjects that interested him as well as making friends and becoming a very good listener.

Looking back, I realise what a huge part of my life the studio was. For some, it was a one-off walk through or they visited it now and again. For me, it was a big part of my life.; I was there from the beginning, watched it grow and develop from a rather scruffy shop and interior into Roberts Renaissance home. I saw all the projects painted there, the library developed, the murals painted. I was there throughout the main events of Robert's fake death and the embalming of Diagnose. I was there when Robert did his sketches at the front of the downstairs studio, when he was preparing for his Last Judgement mural, the stained glass, the Birmingham exhibition. I was there after he painted over his mural and replaced it with three flying ducks. I was there, photographed and painted for many years and so many discussions about art, my life, relationships and people. Much of my life was spent in that studio and I will never forget my wonderful father and his incredible and inspiring life while he painted there.

Chapter Eighteen

Art Lessons

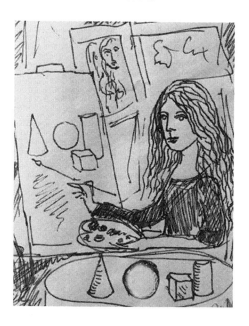

In 1962, Robert's life changed. He had produced a huge amount of work. He believed in himself and nothing ever changed this but things were moving fast in the art world. It was during this time; Robert was honoured to gain a place at the Royal Academy of Art. Mouse was still at St Martins as she was two years below him. Life continued much the same for a while as they lived together happily in London in Eton Avenue. At 4.00pm each evening Mouse would often meet Robert at the Academy gates. Sometimes they went for a

cup of tea in the canteen. This was a different scene from St Martins and looking back, Mouse described it as being a rather 'sober affair'. Mouse looks back on this period, remembering that somehow Robert and the academy "never gelled".

There have been many stories that have surfaced about this period in Robert's life but the main one is always that Robert's work was somehow viewed sceptically and that his work was not with the times. The style of art at that time was more geared towards Pop Art, Minimalism and Abstract Expressionism. At the same time Robert would have been very aware and interested in new concepts of art. He was always interested in contemporary art throughout his whole life and his library contained numerous books on art including contemporary artists, many of whom Robert admired. They were professional in their field and had surpassed important hurdles. Robert had an amazing eye.

I remember Robert showing me books on modern painters he respected. We used to discuss the books in his library and he would place them in front of me. We would browse through the paintings of Howard Hodgkin, Ken Kiff, Cecil Collins and Chagall. He also loved Egyptian art and I will never forget one morning as we both browsed through a very large book with beautiful photographs of golden images of objects from Tutankhamen's tomb admiring those wonderful artefacts and exquisite works of art. I think Robert was directing me towards these artworks for inspiration. He knew I enjoyed colour and ritual and spiritual, abstract and surrealist artists. I did but I also enjoyed Robert's paintings. I always felt there was another level to Roberts portraits. They took you to a different place visually and emotionally.

Robert also admired Francis Bacon and Lucian Freud. I remember at the time both artists were being discussed in art news quite frequently and I always thought Roberts works should have been in

those articles with them. We have to acknowledge that Robert's paintings are up there with the great artists. I remember him showing me the painting of *Study after* Velázquez's *Portrait of Pope Innocent X* by Francis Bacon. Robert seemed to be quite fascinated by these works. Certain works moved him more than others which is only natural but innovation in art held a strong interest for him. Stagnancy was not part of Robert's character. However, in terms of his medium, he was fundamentally into oil paint, canvas and watercolour. These were the mediums he enjoyed the most.

I can't even begin to emphasise just how much Robert taught me about artists and their work but it was regular, almost every visit I had with him. We would go for coffee at Jo Prete's cafe on the Barbican and Robert would take out a book on art and talk about the paintings with me. My earliest memory of him talking about art must have been the work of the Flemish painter Pieter Brueghel the Elder. Robert was particularly fascinated by the painting, *The Adoration of the Kings.* He admired Brueghel because of the artist's fascination with the 'ordinary person on the street'. Like Brueghel, Robert was fascinated by people's flaws, troubles and problems and the allegory of life. Brueghel was very much this kind of painter. I remember when I was a child, Robert showing me how in *The Adoration of the Kings*, the kings, while offering gifts to baby Jesus were all more interested in their own gifts rather than Jesus himself. It always made me smile when he showed me this image. Sure enough, if you look at this painting you will see the kings aren't looking at the Messiah. Robert loved the foolery in these paintings and the satire such as the painting, *The Land of Cockaigne* and the painting of Landscape with the fall of Icarus, who fell from the sky, unnoticed as the world continues about its business. Robert enjoyed this kind of satire.

Then there are the more sublime paintings by Bruegel, *The Parable of the Blind* and *The Triumph of Death*. I feel Bruegel was

significant throughout Robert's work during his lifetime. You will see it in his education project and in the addictive behaviour projects where his influences are similar to Bruegel in the idea of people's obsessions such as money, sexuality and vanity. Roberts's works express a lot of anti-materialism, the idea that money will bring us nothing but misery. Possessions are temporary but at the end of the day we all succumb to these desires.

Robert was far more interested in the human condition and the unaffected things in life. He had little interest in how society labelled people through their financial status. People were people to him and who they were as people was important, not their financial status or their titles. Robert was always primarily a painter of social issues and there were certain artists he always had a closer affinity with. Living for the moment was what Robert was interested in and the thoughts and actions that consume a person's day to day life. He lived every day to the full.

The portraits he painted are there as examples of his interest in specific issues and types of human behaviour. However, a great deal of his time went into meeting these people and learning about his subject before he painted which sometimes, I feel is overlooked. He became very involved with his subject and of course involved with many women and hence he experienced many relationships. I remember Robert made me laugh when we were talking about relationships once. He said, "I don't know why people get so upset when they have problems in their relationship. I have to deal with about twenty of them!"

Robert was also a lover of land and seascape painting if it was done well. I remember him showing me pictures of John Constable's drawings of clouds when I was a little girl. He also admired Turner's seascapes. He was particularly fond of the sea. One of his favourite paintings was *The Raft of Medusa* by the artist, Théodore Gericault.

135

I remember Robert being fascinated by the composition of the painting and the overall suffering and desperation that dominated this scene, particularly as this was based upon a true story. It also contained the 'cannibal' theme; the idea that humans will succumb to eating another human if their lives depend upon it. It also linked to Roberts interest in human anatomy and dissection. Close friend of my father, Tarun Bedi told me that in the earlier years when he had visited Robert in Plymouth, Robert at one point worked as an assistant in an autopsy department and there was a window that Tarun could see through from another building directly into the autopsy unit. Taren told me that once Robert took a decapitated arm and held it up to the window waving it humorously to everyone.

Variations on maritime themes formed a large part of Robert's world and he later extended his enthusiasm for this theme when he lived in Plymouth, observing the fishermen and exploring issues of human behaviour and work carried out locally in his paintings and his exhibitions. I remember Robert was particularly fond of the painter, Stanhope Forbes of the Newlyn School. His painting, *The Fish Sale on a Cornish Beach, 1885* in Plymouth City Museum and Art Gallery was one of Robert's favourite paintings in Plymouth and he took me to see it. I remember him describing the lovely tones, textures and movement in the painting as we stood there on the steps.

I always loved Plymouth museum and art gallery. I have fond memories of visiting it in my childhood. They used to have a huge antique music box. If you dropped two pence into it, it would play the most beautiful and magical music.

I think what is interesting with Robert is that his art encompassed more than just the work he produced. His life was very much part of his art; a 'performance' and I feel he saw his life and his art as intertwined. People came to him because he was talented and didn't

136

fit in. His personal style was individual and he was known for being eccentric but in the end attitudes from the public tended to range between admiration, shock, intrigue and sometimes disbelief.

I remember when I was in my teens Robert took me for a walk along the Barbican. We sat down on a bench, both gazing across the Plymouth sound. It was a misty day with a little sunshine pouring through the sky. We sat down on a bench to admire the view. I never forgot how Robert became absorbed by an old circular gas station in the distance with all its rust and green verdigris ladders and peeling paint glinting in the sun. Robert admired it, saying to me how if it was reduced in size it would make the most exquisite wedding ring. I understood what he was saying but it wasn't until later on that I really identified with this way of viewing the world around me. Robert's sense of vision was incredibly modern for its time. This would have been sometime during 1977.

Robert began teaching me how to paint with the sphere, cone and cylinder. I remember him setting it up for me in his studio. He told me to begin with only black and white paint and to think "think only about the tones. He would cover the forms in white cloth and I would paint away for hours trying to understand the basics of tone. They were useful and I have never forgotten those tonal lessons. Later, he encouraged me to paint self-portraits. I started with pencil then black and white acrylic and worked up to using oil. He often sent me off to paint, trees and flowers. I learnt a lot from this and enjoyed it a great deal. As with the other students, Robert encouraged me to use 'tone of the tone', 'colour of the colour' and 'shape of the shape.' I found this rule useful. It encouraged me to be disciplined. It is what it is. Stick to the rules and you will learn to make it come to life and to be realistic if that is what you want.

Robert also encouraged me to paint from my imagination. He once asked me to use his house in Priory road as a studio. I stayed there

alone for a few weeks. It was cold and beautiful and strange to be there as I had partly lived there as a little girl. I remember Christmas when I was living there with Mouse, Wolfe and Becky. Mouse was with Jim at this point but we were living in the house for a while and Jim was close friends with Robert. I remember it snowing outside. It was beautiful and Robert's garden was veiled in white.

Mouse and Jim had displayed all the Christmas presents in one of the rooms under the Christmas tree. As children, I remember us all being so excited and jumping out of bed and running into the room. Now, suddenly, here I was, all these years later, back again but this time on my own with some white canvases upstairs in the big large room and stone walls surrounding me. The house had been stripped of its old former self. It was quite an ordinary house in the beginning but when I was there using it as a studio it had just begun to take on that first look of something out of a renaissance painting, the old stone walls, the wooden floors and the ivy brushing against his newly fitted wooden window frames.

The renovation had begun and Robert's unique and beautiful style was slowly transforming the house. Robert quite simply referred to it as 'House' as if it was a human being. The character of the house had changed completely from its former design. I would sit there in total silence, painting. It was a very meditative time for me, very peaceful and spiritual. and I remember the ivy glowing like green stained glass through the windows and there was nothing but silence. I had not had that kind of peace to paint before. I painted throughout the day, creating some very soft blue paintings. I still have two of them. One of them is facing me on my wall as I write this.

During this time, Robert was teaching me to blend colour in a very careful way so that the gradations were subtle. Robert's teaching has never ceased to inspire me with my own creative work.

Robert was very good at explaining colour to me. He would always describe each colour in terms of a mood. For instance he would always compare the warm titanium white with the cooler Flake white. He used a lot of Titanium in his work and I think he preferred it. He was also fond of blue, particularly the hue, Prussian Blue. He used this colour a great deal in his early paintings. It had a dark mystical feel to it. He would often discuss the haunting blues of the artist, Edvard Munch and the subdued tones of Whistler's seascapes and then compare them with the mystical vivid blues of Marc Chagall. Other times he would celebrate the vivid ultramarines in the old rococo paintings of Titian but he was in favour of the early renaissance work of Giotto and also fond of Fra Angelico's use of soft pale colours.

Robert also admired the harmonious subdued colour combinations of Piero della Francesca. One of his favourite paintings was *The Baptism of Christ*. He appreciated the careful gradations of tones and harmonies. Robert was fascinated by colour. He was fond of the way the colour white was varied and not just white. He enjoyed the artist Ben Nicolson's work and the flamboyant jewel like colours of Howard Hodgkin. He was fascinated by the vibrant almost violent use of yellows and dark blues of Van Gogh's cornfields. He enjoyed the russets and ochre colours of the Dutch masters. He had a fascination with form and for still life painting.

I remember Robert discussing with me paintings by Vermeer, Caravaggio, Velazquez and Courbet. He was particularly fond of Caravaggio's painting, *The Water Seller of Seville* and the beautiful formation of the containers the man is holding and surrounded by. The realism was astounding. He valued Vermeer's *Woman with a Milk Jug*. He was fond of found objects and the patterns of china and pottery. I remember his love of Brancusi and the famous golden bird. He showed me a picture of its form and beauty. In terms of the colour red, Robert particularly enjoyed Titian and Delacroix. He

was always commenting on the reds in Delacroix's painting, *'The Women of Algiers* and the red splashes of colour in Titian's mythological paintings.

Robert was interested in many artists but I remember one of his favourite painters was that of the French painter, Jean Auguste Dominique Ingres. He admired Ingres for his use of line and I will never forget him showing me a family portrait that Ingres had drawn with such fluidity and precision. Robert had a kind of obsession with Ingres who was fascinated by the use of line. Robert showed me some sketches by Ingres, group portraits of people. The use of line in drawing was always very important for Robert. He was also interested in the way Ingres 'distorted' the bodies of his models. If you look at the painting, *La Grande Odalisque,* you will notice the elongated neck, back and arms of the woman.

Robert told me how carefully and cleverly Ingres had drawn with just a pencil. It was true. The drawings were perfect, confidant, use of lines that depicted the character of his sitters. Ingres was also influenced by Delacroix, inspired by *The Women of Algiers* and created his own interpretation calling it, *The Turkish Bath.* Robert was fascinated with this painting. He commented on the way Ingres had created a linking of lines to create a circular composition and placed colour appropriately. He had also 'deformed' the bodies, the elongated neck and back but he thought it was beautiful. Robert had a fascination with deformity. In his later paintings he brought this in with certain paintings of women where he depicted them rather like insects with butterfly wings, beautifully painted but there was also something quite 'crumpled' and distorted in some of those paintings of women. They were beautiful paintings and looked very delicate and fragile, some of my favourite pieces.

I remember once, Robert had a dream. He told me, he had dreamt he had been crucified to a cross with his hands and legs twisted up

behind him. I think there was also a frog in the dream and he told me, he had combined these into an oil painting depicting himself as crucified in this agonising way according to his dream. He showed me the finished painting. It was a haunting, tortuous picture, almost frightening to look at because it looked so painful. I look back on these conversations on art with Robert and realise how much they have influenced me. I find it so difficult to look at art these days without applying some of these skills for seeing that Robert made me aware of. It is part of the enjoyment of art; I feel to look for these elements. It would be interesting to go through Roberts works looking for influences of the art of Ingres!

Many years ago when Robert used to create quick pencil sketches in his studio on the Barbican, I was fascinated by the way he drew 'eyes'. I remember asking him to show me how to draw 'an eye'. He showed me very quickly. I remember it being very dewy with soft pencil strokes to create form and shadows. The first art book Robert told me to read was The Story of Art by Ernst H. Gombrich. It is a bible for all art lovers. Robert also gave me a book about Marc Chagall when I was quite young. Robert loved Chagall and I remember he wrote on the first page: "Look carefully at the pictures, Alice. They are a Secret World, like inside your head."' I feel Robert helped me in many ways to find my path as an artist but most of all to enjoy it and be inspired. There is hardly a day that passes when I don't want to sit down and create a painting.

My art style shifted at some point in my youth. I became interested in painting from my head. I used Chagall as my inspiration and my works began quite dream – like and post- impressionist and then I found my work went through a journey of changes. I had my first solo show in Oxford in the nineteen eighties. It was a series of about twenty oil paintings, all of women. They were jewel like colours and quite mystical. The exhibition was called 'Horizons'. I enjoyed the two weeks of the exhibition and met many interesting people in

Oxford who came to see it. I remember Robert looking after my paintings for me after the show.

I will never forget a rather amusing afternoon with Robert when years later I came back to collect those paintings and he tried to stop me from taking them. He wanted to keep them stored on The Barbican. I couldn't understand why he was so intent on keeping them. I look back now and I may have the answer; through all my years of travels since my twenties, most of those paintings are now destroyed. I have a couple left that my daughter wishes me to give her in years to come. Robert was looking out for me.

Chapter Nineteen

Where is Diogenes?

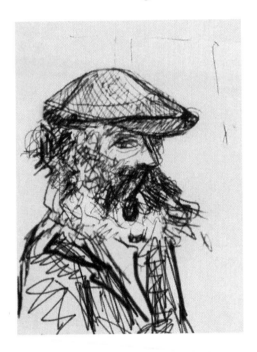

Robert had an obsession with death. He also created many paintings on the subject. He painted his mother when she had died. He put on an exhibition called 'Death and the Maiden'. I remember Miriam modelled for the poster of this exhibition, wearing the paper mask. Robert often discussed death saying the only thing we can ever be sure about in life is that we will all eventually die.

Robert quite often showed famous paintings to me on the theme of death as a symbol of how it was portrayed throughout art history. He owned a few human skulls that were casually displayed on his desk

in his library and apparently Robert had also carried out some grave digging in his time although he never discussed this with me. Robert was interested in painting the idea of death in art. He was fascinated by the artist, Edvard Munch and the dissection paintings by Rembrandt including the images of death by Gericault. Robert enjoyed being reminded of death and reminding others. When he faked his death it was the strangest of times. Many of us including myself went through a period of disillusion and mourning. It was so strange to watch it on the news knowing that he probably wasn't dead but at the same time maybe he could be.

Then suddenly Robert reappeared once again but I remember people weren't that surprised or shocked which was quite unusual under the circumstances. The main time when they were really shocked was when Robert had Diogenes embalmed. Diogenes was Roberts close friend. Robert had known him for many years. Diogenes's real name was Edwin MacKenzie. Edwin was homeless when Robert had accidentally come across him living inside a large concrete 'pipe 'in the woods one day and it was after that unexpected meeting that they struck up a lifelong friendship. Robert painted Diogenes many times. Diogenes always seemed to be there. .I would see him often at Robert's studio. He wasn't very tall. He seemed frail but strong in some ways. He had a beard and he wore a cap and I remember he often walked with his hands in his pockets. I remember his face very well and the sound of his voice. Diogenes watched over quite a few of Roberts exhibitions. He was a polite harmless man and Robert painted him in what I would consider to be some of his greatest masterpieces.

When Diogenes eventually passed away, I think this shocked Robert and he missed him. This was a very special old friend. Little did we know at the time that Robert and Diogenes had created an agreement that meant that one day when Diogenes passed away, Robert would then have the body of Diogenes embalmed and

preserved, possibly for public viewing. This actually took place in 1984 after Diogenes passed away. I was by then twenty-one years of age and had returned home from East Sussex where I was living at the time to visit family.

Once the news got out that this had happened, the press were obsessed and pursued Robert in every way they could to get the story but also a search had been conducted to find the body of Diogenes as Robert had apparently hidden him and been told that he would have to first gain "legal right to possession". The hiding of the body of Diogenes from the authorities had also provoked action by the environmental health officers who wanted Diogenes cremated or buried. Suddenly the most absurd situation took place. The search was on for the body of Diogenes!

It was a crazy time. Everyone was asking Robert where he had put Diogenes. Robert was enjoying the game of the search and would reply with things like, "you are sitting on him" or "he is in the drawer just across the room" or "he has become a paperweight". Robert certainly knew how to make a mockery out of the situation. At one point when councillors came to see what was going on, Robert took the opportunity to lock them all in his studio. They were banging on the door for quite a while to get out before someone eventually came and released them. Robert used to say Diogenes would have smiled at how much more concern there has been for his death than he received alive. Locking the councillors in the studio went into the papers with the heading, 'The Great Escape' and showed a picture of Robert fleeing the studio with the keys. It made people laugh in Plymouth. I always remember a taxi driver at the time who was tickled pink at this news. Robert and Diogenes were completely laughing at the system and at life.

We never heard much more about where Diogenes was kept after that. I think Robert eventually gained permission and everything

cooled down. I will never forget the uproar and the amount of conversation about Diogenes at that time. The years passed and the last I heard was that Diogenes was 'in storage'. Where he was placed, I have no idea but it was very interesting because in 2011, I saw Diogenes for the first time in many years. He was displayed as a work of art at the 'Still Lives' exhibition at The Royal West of England Academy in Bristol. It was so strange to see him laid out in his glass coffin at the exhibition. It didn't shock people but we were all fascinated. In contemporary art; very few things have ever come this close to having a deceased human body on exhibition.

When I was fourteen years old Robert invited me to his house in Priory road in Mannamead. This was the house that I had lived in as a small child, when we all left Cornwall. It was quite a normal house in those days but at this point Robert's dream of how he wanted it was beginning to take form. Ivy was growing on the walls and it was rather wild and quite a bit of construction was going on inside. It was all quite haphazard; the beginning of the house and its innards being turned inside out. I arrived and he took me into the first room on the right as you enter the house. The house was different back then. It became more open and spacious later on but at that time it was quite simply a normal house and not too big. I remember it had a bed inside that room and Robert was at times ill in that bed. He had some aches and pains at times and he literally couldn't walk when he got these flare-ups. It was quite unsettling to see my father on crutches unable to stand on his feet. He was in a lot of pain. It must have been quite severe but we rarely discussed it.

Robert told me he was painting himself on his deathbed and he wanted me in the painting. The room was dark and filled with canvasses. He had a giant canvas rigged up on the back wall with a beautiful painting he had begun and I recognised most of the people in the painting, some of them my brothers and sisters, our mothers and close friends. This painting was Roberts self-portrait, deathbed

scene. Robert wanted me to model for this painting and he asked me to wear a white blouse. I remember holding a candle for that painting. It was a lovely atmosphere. It was dark and there was a renaissance feeling about the room. I particularly liked this painting but I remember feeling quite sad when it was painted and I didn't like to think of Robert dying. He was depicting an idea of his future. He painted it years before his actual death but even then, he was predicting, always looking ahead at what could be. I reflect back to Roberts actual funeral which took place at Roberts house the same place this painting was carried out. In some ways it was similar to the painting. Family and friends were all there and it was the saddest of days.

We couldn't believe that Robert could ever die. He was a big and strong man and his presence was more immense than what was expected of people in society at that time. Robert would live forever. He used to joke about it sometimes and say he would grow old and be like Leonardo, wizened and feeble. I still can't believe he isn't here sometimes. I remember Robert's funeral; I was totally traumatised. I was sobbing at his grave. I had lost my best friend. I think Roberts death had a huge impact on me. Years later I created a triptych painting about that day and my sadness.

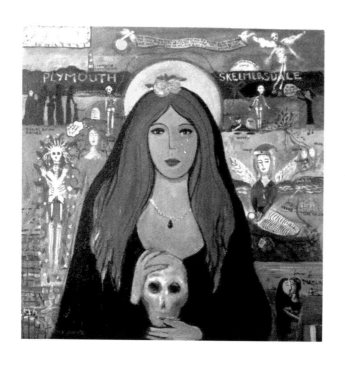

Chapter Twenty

Mark Price - Short Walk with a Dead Man.

My memories of Robert Lenkiewicz raise doubts about the reality of certain events. The first encounter was in The House That Jack Built, a warren of boutiques and antique shops with an indoor waterfall, behind which a spiral staircase led up to possibly the world's smallest cafe. I recall two tables, each with two chairs, so half the space was taken up by the teenage me and my lunch-date. It was going badly. The food was fine but the conversation flowed like mince. I didn't expect my counterpart to be an intellectual but after ten minutes even the monosyllabic answers had ground to a halt. The usual subjects for 1980s youth fell dead - music, art, films, drugs, books, nuclear war. There wasn't even a window to stare out of during the long silences.

Voices on the staircase announced two more diners. The first resembled a Viking berserker who had joined the Khmer Rouge. The second was a wild-looking man half his size but speaking at double-speed and volume. The giant cradled half a dozen ancient books, any one of which might be the Necronomicon. His friend held a heavily annotated theatre script. They shoe-horned themselves into the remaining seats without pausing their conversation which at such close quarters I had no choice but to hear. And what a conversation! They spoke with passion and authority on William Blake and the relationship of the imagination to immortality, quoting philosophers and cross-referencing ideas like jazz masters mining an unstoppable riff. I was awestruck. Even factoring in my youth and impressionability, and that the previous half-hour had primed me to regard a duck quacking as an

intellectual uplift; there was no denying the buzz, the rush of hearing first -rank creative minds at play. No schoolteachers or South Bank Show presenters had one tenth of that energy or zeal. At the time I didn't know that this was the painter Robert Lenkiewicz and the poet Jim Pascoe. But I knew I was in the presence of something amazing. For some time, I closed my eyes and pared myself down to a gigantic ear and a brain. They talked of how imagination creates reality, and Pascoe quoted a long and very beautiful poem about the rationalist hatred for myth which included the line: 'There are no unicorns, or if there are, we will find them and kill them'. Never could find that poem. I think it was one of his, sadly unpublished.

Robert talked about Apollo and Dionysus and Nietzsche's collapse of the distinction between reality and appearance, and how the 'Real World' becomes a myth. All of which sounds terribly heavy, but they were laughing and joking as they developed their themes. Damn, I thought, these guys are not just philosophical – they're casually philosophical – in sharp contrast to my spotty teenage pretentions. I yearned to join the conversation but was painfully aware of how out of my depth I would be. So instead I ordered a Victoria sponge I didn't want and gorged myself on their profundity until they left.

That memory is dreamlike – the cafe too small, their personalities too huge, my companion too silent, and everything wrapped in a subterranean Alice-In-Wonderland aura, as if the archetypes of Poet and Mage had spiralled up from a deeper level of my unconscious. But it happened. I'm sure. I recall it just as clearly as I recall body guarding the corpse of Diogenes.

Seldom is the word 'bodyguard' used so literally. Three days and three nights I spent next to his cadaver – it was in a white body-bag in a plain coffin on the other side of a large canvas, so not as Gothic as one might think. Robert was away in London when gangsters rogue City Officials or journalists broke into his studios looking for

the corpse. In this they failed, but lest they returned preparations were made for a siege. This was not his main studio on The Parade but a secluded barn-like building set back from Hoegate street, easy to defend because the only approach was visible from the window, and the stairs so narrow only one person at a time could ascend.

Fortunately nobody did until Robert returned. It was night-time and he, myself and Dave, 'The Builder' Johnson were discussing the situation. Dave was a bright-eyed cube of muscle with a reputation as a ferocious brawler, though why anybody would fight with such a jovial chunk was beyond my imagination. Almost silently, an estate-car with no headlights crept up the backroad. We didn't see the occupants but suspect they saw us, for they made off in reverse with a swish of gravel. It wasn't conclusive proof of anything, but Dave had good instincts for trouble which Robert trusted as well as his own. 'We should move Diogenes tonight' said Dave, and so we did.

Barbican nightlife and its symbiotic cops seldom vanished until way past the witching hour so we waited until the streets were dead before bringing Diogenes down. A coffin can't be disguised - not with coats, sheets, or a roll of carpet - especially not when carried around at three in the morning. It was a lightweight affair with the build-quality of an orange box: coffin and corpse together probably weighed no more than fifty kilos. Dave or Robert could have shouldered it like a bag of cement but for the balance problem. Our journey led down Blackfriars Lane, a sloping and treacherously cobbled alley. The height differences between all three of us made it a complex though comedic affair. This was the first time I had concealed a body from the authorities so there was new and very specific sense of excitement and conspiracy as we took turns as look-outs and pallbearers. Dave whispered from the front end 'Mind your step here, boy, don't slip' as we approached some uneven patch near Southside Street, I said, 'at least it's not raining'. He said 'Rain'd be good. People don't look round; sound doesn't carry so

151

far'. I was as grateful for Dave's expertise in skullduggery as Robert and Jim's intellectualism. Sneaking around with a corpse feels sightly more normal if somebody knows what they are doing. We hung back in the alley while Robert went to the main studio to open the doors up on the second floor. This was the danger zone.

Southside street was the Barbican's busiest road. Barmaids and bouncers finish late, fishermen start early. But it was the only way into Diogenes' new hide-out. There was no way in via the tightly zig-zagged stairs of 25 the Parade. Robert's plan was to hoist him in through the loading-doors of the old McMullins' warehouse, fifteen or twenty feet above the pavement. An antique pulley system was still in place. We heard Robert open the doors open and lower the ropes, and we rushed with our cargo out of the alley into the glaring streetlights. From here on it was down to luck. Hopefully nobody would walk by and no cars – please, please no police cars- cruise around the corner.

We set Diogenes on the pavement beneath the loading bay. Deft as a mariner Dave rigged a rope cradle. No nooses, but one rope for the head and one for the feet so the loaded coffin would not shift in its ascent. Dave double-checked and choked the knots. Above us Robert took up the slack while Dave ran around via the next alley to 25 The Parade, up the zig-zag stairs, through the connecting doorway he had knocked through only weeks previously, into McMullins' warehouse to join Robert at the bay doors. This he probably did in seconds rather than minutes or aeons, however it might have felt to me. The ropes tensed and Diogenes began his ascent. The coffin rose slowly, steadily, and level. Above me, inside the warehouse Robert and Dave had to stand back from the edge to haul away. This meant they could not see what was happening outside and below. If things went wrong, I would have to call up loudly for a halt. So it was with some horror that I saw the coffin catch against the wall and begin to rotate on its long axis.

Afterwards I made the joke that Diogenes would have been spinning in his grave if he had one. But there and then I was close to panic. My memory is full of the smell of the embalmed Diogenes, a heady mix of pear-drops and marker-pens. Robert told me this chemical mixture drove the water out of the cadaver by slow degrees until it was eventually desiccated as any Egyptian mummy. Eventually. But Diogenes was not yet fully desiccated. I had a stomach-churning image of the fragile box falling and Diogenes, still mushy within his part-dried carapace, splattering on the pavement like a part-cooked pavlova. I shouted – or more likely shrieked like a small girl 'STOP!'

Diogenes hovered in empty time until Robert appeared at the doors above. I whispered loudly upwards: 'He's snagging on the wall'. Robert vanished inside then returned and did something I thought might kill him. While Dave pulled both ropes, Robert leaned far out of the building holding first one, then both of the ropes away from the wall. He shifted his balance left to right and forwards to backwards in an attempt to dance the body aloft. At that point I had what alcoholics refer to as 'a moment of clarity'.

Persons of Robert's size and weight – if very lucky – might survive such a fall. And resourceful people – very resourceful people like Dave- might be able to take charge of that kind of situation. Two minutes earlier I worried about Dave and I being caught red-handed by the authorities who had sworn to recover and incinerate the corpse. One minute after that, I worried that Robert might have to run a hundred yards to Karen Ciambriello's house to borrow three spatulas to scoop Diogenes' remains back into his body bag. Suddenly I was worrying about standing on Southside Street at 4 AM with the corpses of the long-dead Diogenes and the newly dead Robert Lenkiewicz. This wasn't the kind of thing I'd like to explain to the authorities, or Karen, or the wider world.

A rope was thrown down to me with one end looped over the coffin so when Dave resumed hauling and with Robert, puppeteering we could awkwardly steer it away from the wall. In a final dash Robert leaned far out and hoisted the coffin over the threshold. There was a scrape of wood and iron, then the doors closed. An empty street never looked so beautiful.

The strange journey took no longer than it has taken you to read of it, but it was a formative experience for me. I was twenty-two, moderately intelligent but over-sensitive and emotionally retarded for my years. I was alienated from all family, living chaotically, veering in and out of work and drugs and violence. Robert took care of me. He fed me. He taught me to stretch canvases and my intellect. He introduced me to interesting people and beautiful ideas and dangerous artworks. You could toss the words of that last sentence like a salad and it would still be true. I enjoyed Robert's friendship for five years in the 1980s: hardly a footnote in his biography. But almost twenty years after Robert's death I am still - ever again anew - meeting people who spent decades with him who carry the beauty and interest and danger of those days. He inspired people, he was a catalyst for the thought and the feeling that anything is possible and can with appropriate efforts be made actual. In this respect he was and remains a true alchemist.

Perhaps much of the above sounds like nostalgia or blind adoration, but trust me, I am no uncritical acolyte. An early but hard-won escape from the worst excesses of Catholicism destroyed my talents for disciple hood. Robert could easily have played the role of aesthetic guru, but as far as I saw he reviled 'followers'. All I knew at the time and all I have discovered since, suggests Robert favoured an anarchistic milieu rather than a hierarchical one. He cultivated relationships with beautiful and stunningly intelligent women, many of whom were accomplished writers and academics and artists. His male friends ranged from builders to 'old money nobility', to

professional fighters and movie stuntmen, to canny Jamaican poets and Indian artists who taught in the toughest political prisons of America. Add to this list a brigade of 'dossers' who would not follow Jesus Christ through the doors of Paradise on the promise of an unlimited supply of cider, not unless they actually saw and tasted the goods first. Followers bored Robert. He was always interested in individuals.

The suddenness of his death gave me no chance to thank him for all his 'provocations to thought - and action. Robert encouraged my interest in philosophy, prompted my first PhD, and his advice almost certainly saved my life on one occasion – though characteristically he set out the odds then said, 'It's not my advice, merely my opinion'. At the other end of the life-death spectrum, I attended my first real nativity when Karen gave birth in his studio. On another spectrum entirely I smuggled the severed head of a mutant diceaphalic goat into the country as a gift for him, and so on, and so forth. Such adventures were the best apprenticeship I could have had before moving on to stranger pastures. Robert inspired me. He still does.

Chapter Twenty-One

Lee Benson

Hi Alice
Here are a couple of memories.

Memory 1
The phone rings in my gallery
'Hello' I say
In a soft deliberate voice I hear.
"This is the artist from Plymouth. You must understand my
predicament. The girls are exhibiting at the Spring fair and I assume
you have my paintings on show '
'And what you're asking me is to hide them for a few days?'
'I do not wish for them to see what I've given you'
A lovely situation whereby Robert likes to play a game of hide, sell
and conceal from his workforce. I'm happy to slightly conceal the
paintings but as it's a busy time I add 'Surely you would like me to
sell them sooner rather than later?'
Well if you sell them by tomorrow that would suffice'
'I'll do my best '
Before I could say, goodbye the phone had gone quiet.

Memory 2
Early in the nineties when I met Robert in his studio, I found myself
in his library without the rest of the group. Robert was trying to
figure me out, so I asked him with all the books he owned and read,
did he believe in God. He replied there are several hundred gods and
religions so could I be more specific

I smiled and said the wonderful thing about philosophy is there is no real answer just theories and quoting from the books does not quantify whether you believe or not. Time passed rather quickly actually it was well over an hour before we both joined the others walking around the studios

Where had I been? Answer - lost in a philosophical debate with hundreds of books and one man.

Cheers Lee

Chapter Twenty-Two

Ted Whitehead & Don Brown - Memories of Robert O. Lenkiewicz

As a long-standing admirer of Robert's work, I jumped at the chance to meet him in the 1980's. The manager of a residential home where my niece with learning difficulties lived told me that June had been invited by Robert to his studio on a Sunday afternoon and needed to be accompanied. I collected June, who was very excited at visiting Robert. We climbed the staircase to be greeted by Robert and Esther Dallaway and made to feel very welcome. It appeared that June had approached Robert while he was having a snack in Prete's café and more or less invited herself. It was a very pleasant afternoon at the studio and I even managed to impress Robert with the quality of the colour in the Polaroid photos we took. In 1993 I asked Robert if he would do a portrait of my partner and me.

He said, "No, I don't do private commissions" - to which I replied that it was worth a try - "if you don't ask-you don't receive" - and I started down the staircase of his studio. I had only got part way down when Robert shouted, "Stop - come back". I retraced my steps and on reaching Robert he sat down on the stairs and said, "tell me why you want your portrait done." I explained that we were having our relationship of 33 years blessed and we wanted something special to mark the occasion: a painting by Robert would be ideal. Robert wanted to know how we had met and asked a lot of questions. After a while he said he would be happy to do a painting approx. 3ft square, and he would frame and glaze it. He was a little shocked when I said I wanted it for the ceremony in 6 weeks time but agreed he could do that, and I left the building hardly able to believe our luck.

The following Thursday we had our first sitting in the studio. Robert told us to wear the same clothes for every sitting and not to have a haircut until he had finished. He allowed us to look at the painting after approx. half an hour and we were amazed that already we could recognise our rough outline. I had been surprised at the size of brush Robert was using. I said to Don at the time it was the size we would normally use on the ceiling and yet Robert was being so creative with these seemingly large brushes. He very quickly cleaned the bristles against the canvas - clearly visible in the photos we took of the painting after each sitting.

As the weeks progressed, sometimes on our own, other times together, Robert asked countless questions about our relationship - occasionally painting while eating an apple or a piece of cake. He had the knack of making you feel that you were the most important person he had met and he wanted to know all about our lives. He was so interested in my account of witnessing an H-bomb explosion on Christmas Island in 1957 that I promised to lend him a booklet and other memorabilia on the tests. Don reminded Robert that they had met 20 years earlier. "I was a Social Services Manager in Plymouth, responsible for the needs of single homeless people. We knew Robert had been supporting them privately and was producing his first project Vagrancy. Robert and I were invited to a live evening discussion at the local Westward TV studios, together with the Rev Gordon Wright, who was involved with the Bath Street Mission. I remember Robert's eloquent argument for public money to provide decent accommodation for these men. I had the unenviable job of defending the local budget-spending.

Earlier I had attended the opening of his Vagrancy exhibition on the Barbican. Robert tried (unsuccessfully) to get the Director, Mrs Taylor, to attend. Over the years he delighted in confronting senior civic dignitaries to plead his causes! Robert encouraged us to take photos as the work progressed and at one point asked me to bring

something of special interest that I could hold in my hand. We decided on a Wedgwood dish that was Don's first anniversary present to me and he painted it in such wonderful detail. He was very impressed with our length of relationship but thought that we were depriving others of getting to know us and love us - he said he thought 2 weeks was quite long enough to be in a close relationship with one person!

Throughout this period we were in the process of selling our Dartmoor small-holding and buying the neighbouring old vicarage. However we were let down by the agent and suddenly found we had sold our house and had nowhere to move to; we finally ended up in Hartley, Plymouth and much of this anxiety shows through in the painting! We had our last sitting exactly 6 weeks later on the Thursday when the painting had no background at all. Two days later the finished work was delivered to our home by Dave and Luke in time for the ceremony - we were overjoyed. Dave said Robert advised us not to lean the painting forward or face down as the paint was still wet - and also to tell us that he had painted himself into the picture as a present for us but would take his image out if we didn't want him in it! Could anyone not want such a present from Robert? The painting was unveiled in front of our guests the following day to a mixed reception; some thought it superb while others had reservations. I told them what Robert had told me to say some time before - "if any of your friends don't like it and say it doesn't look like you, tell them to take a photo of you. This is art and this is how I see you" For the next 5 years the painting took pride of place in the dining room.

Later when visiting an exhibition on the Barbican I complained that I never had the opportunity to buy any of Robert's portraits of his models, and the Gallery owner advised me to go up to the studio at the earliest opportunity as Robert needed to pay some bills. This we did and while I was shown several partly finished paintings around

the floor, Don had been looking through stacks of paintings that were in the back room which housed the fourposter bed. He suddenly called me. To my amazement he had found a portrait of my niece painted in the mentally handicapped project and signed on the back by my late brother and late sister-in-law and also by June herself. Although it wasn't quite finished, it was a very good likeness, catching her with her usual slight frown. I'd had no idea of its existence, but felt it had significance for the family. I agreed a price with Esther and was writing a cheque when Robert appeared. Shaking me warmly by the hand, he asked what I was doing, and when I explained he said, "I'm sorry but I cannot sell it to you." I assumed he meant he was withdrawing it but he astounded me by going on to say, "Please accept it as a gift - pass it to me and I will sign it" adding "this won't do my financial situation any good at all!" I thanked Robert profusely for his generosity and promised to buy another painting. Esther showed us several that were in various stages of completion and we decided we both liked one of Lisa kneeling with her arms resting on a cushion draped over a chair. Her hair was tied on top of her head but Robert later changed the pose to let it cascade over her shoulders at my request. Robert agreed a price and said we would be telephoned when it was ready; two years later we collected it framed and ready for hanging. Around this time I read an article in the local paper that there was to be a sale of Robert's early sketches and watercolours at Isabell's framing shop and long queues were expected early on a Sunday morning. I told Robert that, suffering the same complaint that he had, I wouldn't be able to queue for several hours. As understanding as always, he told me to tell Isabell that he had ok'd it for me to have a preview and make a purchase if I wished. Isabell very kindly let me wander around the back room and I purchased a small pen and ink sketch that Robert had inscribed "Anna combing her hair while watching Eastenders".

One of Robert's exhibitions included an evening with guest of honour Lesley Joseph, the actress, whom Robert was painting. Robert beckoned me over to assure me that my Christmas Island memorabilia were quite safe but I never did see them again because after his death his executors couldn't find them.

Robert's major exhibition at Plymouth Museum in 1997 was memorable, with Les Ryder as guest of honour together with Terry Waite. Both signed my brochure along with Robert, with Les signing "Les Ryder also known has (sic) King Ryder". When Don and I moved back to Yelverton we discovered that Mouse, Robert's first wife, and her husband Pete owned our local store. Renowned for her kindness, she said Pete would help Don hang our own portrait above the landing window. They made an excellent job of it, but sometime later I was told by a gallery owner that I shouldn't hide a Lenkiewicz painting out of visitors' sight. He was very surprised when I told him I had a series of colour photos of Robert and his work in progress. I discussed it with Anna Jones a Trustee of the Lenkiewicz Foundation who owned a Plymouth framing shop, and she and her husband Phil spent a delightful afternoon re-hanging our portrait in the hallway surrounded by 6 black framed photos. They have been admired by all the visitors to our fundraising coffee mornings.

Since first meeting Robert, I have built up an archive of newspaper cuttings, photos and exhibition previews. In addition, at Bearnes auction of Robert's estate I bought a 5ft high carved wooden figure of Robert which was created by Peter Blackler and inscribed "Inspiration." Despite being a very good likeness it seems to have been hidden away, since none of Robert's close friends remembered it. Perhaps Robert felt slightly embarrassed by this reference to his talent to inspire? All best wishes with the book.

Chapter Twenty-Three

Sufism in Plymouth

Many stories have been told about Robert and magic. I myself knew very little about any involvement Robert had with any belief systems until I spoke to Lemon. I knew that he was interested in the occult and books of Renaissance occult magic and witches and he had shown me the secret magic bottle he owned that dated back centuries but I always thought this was more out of interest than anything he would actually practice. It has been interesting for me to discover recently that Robert did actually become interested in the occult and spiritualism on a more practical level.

Here is an interesting story that Lemon, a close friend of Robert told me concerning Robert's connection with Sufism in Plymouth which conveys much of the atmosphere of the time. It is strange because I remember very clearly those little crystals that people were wearing and many of the symbols in Robert's house when I was a child. It was good to finally have this clarified by Lemon.

At the time a number of people were interested in the ideas of G. Gurdjieff, P. D. Ouspensky, J G Bennet, etc (there was a whole group of writers and occult practitioners associated with theosophy and eastern mystical traditions) that some people discussed.

Robert was holding 'readings that were taken from The Dawn of Magic by Bergier and Pauwels. A few days after one of these readings Robert discussed some of these ideas. He recommended people read 'The Sufis' by Idries Shah. A few weeks later, at the house in Priory Road, Lemon became impressed with this book and borrowed a copy of Tales of the Dervishes. Robert suggested that he write to Shah asking him how he could take these ideas further. They discussed it and Robert typed it out.

He asked Lemon if, when he received a reply, could he resist from opening it until he came down to his house in Priory Road. In about a week the reply arrived and Lemon dutifully placed it, unopened, in his pocket and set out for Robert's house. He got there and reached for the letter and it was gone – somehow it had dropped out on the way. Lemon was frantic – He could hardly write again saying 'Sorry Mr Shah, I got your letter but I lost it could you send me a copy'.He told Robert that this was his entire fault with his crazy idea of having him bring the letter all the way to Lower Compton before seeing the contents. At the time, Lemon thought this letter could change his life, and to blow it first from the start was, well upsetting to say the least.

Robert suggested that they wait a few days and see what happens. Lemon agreed and the next day the letter arrived at his house, with a muddy footprint on the envelope but still unopened. What clearly had happened was that someone had seen it, picked it up and posted it unopened. This, he was sure, was a sign that something was influencing events.

Lemon was in his late teens at the time and it was arranged that he meet with a Dr Musgrove. It became clear that a number of people in Plymouth had already established contact with Shah and that a 'study group' had been convened. Lemon can't remember who took

him to Dr Musgrove but after the meeting he was invited to join the group.

The group would meet at a friend's house in Plymouth every Thursday. The format of the meetings would be in 2 parts the first parts consisted of Dr Musgrove reading from Shah's work. Then a social part when we had tea/coffee and a chat.

After a while the format changed to them selecting the readings and discussing the content. Lemon can remember that he usefully went for a Nasruddin story. Robert once read the Islanders from The Sufis and on another occasion the Magic Horse. Notes were taken and distributed during the following meeting. (Lemon still has some of these entitled 'interpretations') Dr Musgrove would also give them pieces from Shah that were not available to 'the public'. (Again Lemon owns some of these) After a while a breathing exercise was introduced and they were given a small crystal each. Lemon can remember that one person lost hers and he asked Dr Musgrove if he could share his crystal with her.

They were encouraged to visit Shah in his country house in Langton Green, Kent. They were to write and be given a weekend slot. Lemon went with friends and drove from Plymouth to Kent in his old Austin car (it took all day!). When they arrived, they were told that Shah was away but to 'make themselves at home'. The house was set in its own large grounds. Lemon went for a walk and met an elderly gent with a shock of grey hair, cutting the grass in an area behind the house. He stopped and chatted and he told him he had just run over a vole or shrew and was a little concerned that he had killed it. Lemon left him to it and had a look at a strange geodesic dome building in the field behind the house.

That evening they had a group meal and at the head of the table was the 'grass cutter'. He was introduced to them as Robert Graves. He

had no idea what Robert Graves looked like so hadn't recognised him earlier that day. He and friends seemed to 'hit it off' and listening to the conversation was fascinating – Graves talked about how one's name might have an influence on one's life, about his friend Robert Frost and about his travels. They drank wine (Langton Hose Wine) which had a drawing of Nasreddin, the label showing him treading grapes with the words 'Untouched by human hands. Lemon left Plymouth to go to Bath (this would be about 1975) and was told later that a communication from Shah to the group had said 'as the group continues to do nothing it will be disbanded'. This may have upset some people and some even felt betrayed.

Robert told Lemon years later on one of his visits to Plymouth that Dr Musgrove had been involved in the Gurdjieff 'work' and had seen Shah as the natural successor on this 'esoteric path' but had died a disillusioned man. The strange thing is that Robert had kept that initial letter from Shah which had caused Lemon such stress on being lost. He kept it with some other sufi documents in a small ring binder behind some books in the library above the shop.
Robert explained how the Plymouth group started and he told Lemon that someone had gone into a bookshop in Cornwall Street to collect a book by IdriesShah and a man had said to him 'If you're interested in these ideas you should contact this person, and gave him the address of Dr Musgrove –so the whole thing started.

On one visit to Plymouth Lemon told Robert that he was planning to visit Syria (this was before the Civil War, obviously) and that he would go to the Mosque where Ibin Arabi and bring him back some Baraka, Robert laughed. The last meeting Lemon had with Robert he discussed Sufism (amongst other topics) and Lemon said that he had re-read some of the original papers that the group had been given. Robert dismissed the Shah stuff saying it was all rubbish. Clearly Shah was not what he claimed to be although in his experience, there is more to these ideas than first appears. There is a

166

sufi saying which goes 'Fool's gold can only exist because there is such a thing as real gold'

Lemon in his own words

I should say a little more about this diagram. You may remember seeing it displayed in your mother's house. Each member of the group was given an A3 size paper with just the diagram printed on it. Your father had his framed and placed above his desk at the house in Lower Compton. We were not told what it represented but later I was shown a short, animated film (it might have been on the visit to Shah's house) in which the diagram broke into its constituent parts (the 8 individual squares) and then reassembled itself into the eight -pointed star. It was meant to represent the group – that each member of the group made a contribution and that the whole was more than the sum of its parts (Gestalt). I have since read about the diagrams used in Islamic Art – superficially the development of geometrical shapes and diagrams into very sophisticated patterns was, we are told, as a direct result of the ban on representing life forms in art. But this may not be the whole story – for example in Persia and Mogul dominated India the human form, animals and flora was widely depicted in decorative art. It could be argued that the use of these diagrams is akin to the way Mandalas are used in other traditions. This is a photo I took in at a Buddhist Monastery in Bhutan, Apparently, they are an aid to meditation both in the process of creating them and contemplating them once they are completed. In Islamic culture a repeated pattern is often used in

tiles, carpets and stained glass. This is a photo I took in Iran of one of the famous Mosques.

There are many publications about the technique of producing these geometric shapes and their possible meaning – interesting reading if you're into this type of thing. I was told that with the diagram like the one we were given, when replicated/repeated into a continuous pattern can represent the 'breath'. Inhalation = the 8 pointed shape, and exhalation = the shape between them. Also Expansion and Contraction. You will know that Rumi's famous work the Masnavi starts with lines about the Ney (flute) and the player's breath being like a cry of separation. The longing the individual feels to be connected to the 'whole'. Sufis use a breathing technique during meditations call Zikr (literally 'remembrance') This practice of Zikr is supposed to bring one close to the universal. Of course we were not told any of this – I'm not sure if it makes any sense to those not versed in sufi practice but it's fascinating discovering the many levels of meaning attributed to a 'simple' design. Robert designed a 'letter head' including a similar 'Islamic' design. I don't know if you saw a copy, he used it for a while then dropped it.
(Alice – Yes, I remember it!)

Of course all of this may be all be rubbish but your father instilled in me this kind of 'detective' pursuit.

Have you come across the saying 'Seek knowledge even unto China'

Take Care
Paul

Dear Lemon,

Thank you for your writings. I find this very interesting. I have always had an interest in Art and Spiritualism. We must keep in touch about this and I would love to explore Sufism further.
I recently created a tapestry based upon Kuan Yin, the Chinese Goddess of Compassion. I have also created quite a few mandala designs in my art. Maybe, subconsciously I have absorbed all of this in my childhood as I have always had a fascination with sacred art and symbols.

I look forward to discussing it further.
Best Wishes
Alice x

Chapter Twenty-Four

A Day in Westminster

I recently received a letter from a good friend of my father and mother, Derek Winkworth a friend from way back in the sixties and when Robert was at the Royal Academy. Derek and Robert were both there together. I am very grateful to Derek for providing me with further images of the day that he, Mouse and Robert all spent together in Westminster.
Message from Derek, 16 December 2011 19:59, Derek Winkworth

Hello Alice,
I have just read your memoir on your website. It brought back many nostalgic memories from the 1960s. I was in the same year group as your mother Celia along with Monica Peiser and Rita Palmer (who became good friends) as well as Philip Ward-Jackson and Pierre

Sylvere. Like your father Robert, I went on to study at the Royal Academy after St Martin's. I remember well the common room with Monica Meyer dancing (also a good friend), the Book Cafe where we ate Italian meat balls and the Loft where I arm wrestled with Robert (always a stalemate). Other people I knew well were Aury & Myrna Shoa along with Milton Delaney. So, lots of nostalgia for me. Just over 10 years over I sent on to Plymouth (via John Pollox, a childhood friend and potter in the Barbican) a series of photocopies of photographs of Robert, Celia & myself at Westminster. I remember the day well: we had my camera & a roll of film & we had a lot of fun. I notice on your slide show you show only 3 photos from our day out in Westminster. There are another 8 & I wonder if you have them or want them. I'm sending on as an attachment one of your mother. Let me know if you want the others. Towards the end of the 60s our paths went different ways. I went into education so have seen very little of your parents since. Just before your father died, I received a large book of Robert's work with some very kind words that were very appreciated. Like you, I could not understand Celia's nickname. She is a free spirit, more of a lioness, never a mouse. So, many thanks to you for your reminiscences and my best regards to your mother when you next see her.

Derek Winkworth

Dear Derek,
Thanks so much for your email. Mouse will be very interested. I will send this on to her. She doesn't have email but I will print it off for her. I'm sure she will be overjoyed to hear. Thank you very much and thank you for the photograph. I have seen this picture but my sister has it on her wall and I have always wanted one for myself so it seems that I do now have a copy also. It is lovely to have Mouse's memories confirmed by someone who was there. Thanks very much. It is as if you have brought it all to life once again.

Derek

It is very strange hearing you talk about the 'common room'. How amazing! Mouse always used to talk about it with me with such fondness. Strange also, John Pollox was part of my childhood and I remember him well especially his lovely wife at the time, 'Jill' and her son Kier.

Alice:

They visited us at our house in Stoke, Plymouth, quite often having chats and coffees with Mouse. I used to love John's studio on the Barbican and all his pottery. He was very talented and a good friend of Robert's. I have missed Robert a lot, more so lately. Thanks so much for getting in touch with your memories. I would love to see the images and I will let Mouse know you contacted. I know she will be very happy.
All best for now.
Alice

Hello Alice,

I am delighted that you enjoyed the photos & memories. I am sending on the full set & 1 other as an attachment. Please do add them & of course make sure Celia sees them along with the rest of your family. There are many things that I could tell you about that period in the 60s & if you want, I can send them on later. Just a little resume of that day, (Half a century ago!) in Westminster:

We started off at Trafalgar Square, probably after visiting the National Gallery. We walked down Whitehall where Celia & Robert mimicked one of the horse guards at Horse Guard Parade. I am certain (if my memory serves me right) that the soldier said to Robert politely out of the corner of his mouth to p... off!

Later, at Parliament Square, Celia stood next to a young policeman imitating his stance. Then on to Parliament. Celia then stood

amongst the gloom of Rodin's Burghers of Calais holding one of the
Burghers' hand & sucking her thumb like a child. Robert then
offered a 10 bob note to the hand of one of the Burghers.

Then on to Westminster Bridge where Robert stood on a rostrum
giving a maniacal political speech watched by a group of very smart
& proper public-school girls. Robert's dress sense was always
comfortable: at first Robert was reluctant to hook up his loose
trousers using a pair of braces (not sure if they were his or mine) to
just below his armpit, but finally agreed for the sake of the
photograph.

Then we went down the steps to the embankment where Celia led
Robert with the braces as if they were a leash, with Robert
slobbering & growling whilst Celia remained utterly aloof.
On to the final image of your mother looking into the face of the
lion. It was a typical early 1960s students' day out, full of light-
hearted fun, Celia with her wild eyes & sensible clothes & Robert
with his comfortable but considered image along with myself.
The final attached photograph is of me sitting in that infamous
common room which drew you in like a magnet, waiting for the
action to begin.

I do have other photographs (not many) and some updates of Celia's
& my cohort at St Martin's. Some have gone on to be successful
painters & others (like me) in other walks of life.
It was good to see you mention John Pollox. He literally lived a
hundred paces from my family home in North Islington.
My best regards to you and your mother. I'll get back to you with
further information and images if you so wish. Merry Christmas &
Happy New Year

Chapter Twenty-Five

John Pollex - Memories of Robert, Mouse and Derek

Painting of John by Robert

My earliest memories of Derek stem from our school days back in 50's and the flats where we grew up in Islington in London. We both attended what was then Tollington Park secondary central school for boys. I recall Derek was good at art and distinguished himself by being accepted as a student at The Royal Academy of Arts where he met Robert and also Mouse.

I lost contact with Derek until the time he was lecturing at the London School of Fashion and he saw my pots in a gallery window in Soho. We met and chatted about Plymouth and Robert's name came up. I told him Robert had a huge studio on the Barbican. He

also mentioned he knew Mouse who was Robert's partner at the time and that they often went about together.

I also met Uri during my time in London.
I moved to Plymouth in 1971 and set up my studio and workshop in an old warehouse in White Lane on the Barbican. About this time Robert established his studio in a warehouse in the Parade at the other end of the Barbican. I soon made friends with Robert and enjoyed attending his exhibitions in various venues around the Barbican. We occasionally met in the fisherman's café opposite the fish market for breakfast (now Platters fish restaurant). Robert was always interested in my work and my travels abroad lecturing and demonstrating my pottery methods.
In the mid 70's I was going through a difficult time and asked Robert to draw me. We had an interesting conversation about relationships during the sitting. The outcome was an amazing pencil portrait which captured my feelings at that time.

Around 1979 I lived in a flat next door to Robert's studio. Robert was working on a project 'Gossip on the Barbican' and asked me to sit for him for it. At that time Robert was painting on the ground floor behind his shop front. I think we had about seven sittings, I was holding one of my large commemorative dishes with a Lion image wearing a crown on it. I also wore a glove on my right hand, as it was so cold in his studio. This aroused some curiosity amongst visitors to a big show Robert had at the city museum and art gallery. I was asked on several occasions what the significance of the gloved hand was. I suggested they ask Robert as he often put symbolic references in his paintings. I often wondered if he made up an amusing answer to their queries.

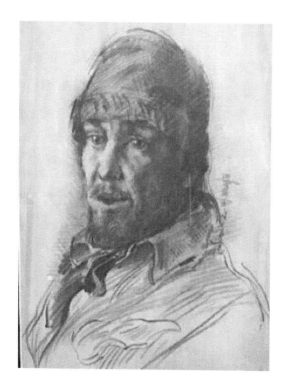

Another exhibition I sat for was the "Addictive behaviour" project. Robert wanted to paint me surrounded by my pots; I wasn't very keen on the idea and suggested that I had two sorts of addictions that were with me before I became a Potter. The first one was my obsession with football and in particular the Arsenal Club, this was from the age of 10 years. The second was meditation which I got into in my late teens. So I suggested I wear one of my replica Arsenal shirts from the fifties and sit crossed legged and meditate whilst he painted me. This turned out to be an interesting experience for both of us. I kept my eyes closed and was focusing on the sounds of Robert painting; the brush hit the canvas quickly to begin with and then slowed down as the first statements were established. There was also the clinking of the brushes as he rattled them in a

jam jar to clean them. After about forty minutes he very slowly approached me and in a very quiet voice asked me if it was all right for us to finish. He also commented on how methodically I had taken my shoes off and placed them beside the cushion I was sitting on. He also liked the fact that I didn't move during the sitting.

On one occasion Robert and I visited the Tate at St. Ives with two friends. We went to see a small show of Mark Rothko's paintings. During the visit Robert was recognized quite a few times by locals and other visitors. He was always polite and engaged them in conversation.

Another strong memory was the huge retrospective exhibition in Birmingham. I organised a double decker bus to take Robert's local enthusiastic followers to the show. It was a full bus with around seventy passengers on board. The exhibition was organised by the Washington Green Gallery and was a huge success and gave Robert an audience outside of Plymouth and the West Country. He quickly became a bit of a celebrity in Birmingham during his stay there, appearing on T.V. and in the Birmingham newspapers.

I also found Robert to be very generous with his time and got to know many of the students he taught for free. As long, as they were serious and did their homework. His generosity extended to giving me a generous financial gift for introducing him to a couple of my friends who were keen to invest in his paintings. I arranged to meet him and mentioned my friend's wishes. 'Oh how much money are they able to spend' he curiously asked. ''Around, £25,000'', I replied. He was interested. He asked me if I could bring them to his secret studio in Howgate St on Friday at 4.30pm'. This I duly did. After a few weeks had gone by I bumped into Robert and Anna at the ABC cinema. Robert beckoned me over, "I'd like to thank you for introducing me to your friends, it got me out of a spot with a book dealer, would £??? be alright". "That would be very generous

of you Robert" I replied. He instructed me to go to the main studio at 9am the following day and it would be there for me. The following morning one of Robert's assistants opened the door and gave me a hand made envelope with my name neatly written on it. Nice touch Robert!

There was also the time Robert faked his death. I was in New Zealand at the time with my partner Pam. Some friends contacted me and told me the news. The first person I saw when we returned as I drove into Basket Ope was Robert! I laughed, as I knew he had a wicked sense of humour and said to Pam, 'he'll be walking on water next'.

Whenever any of my artistic friends visited from London, I always took them to see Robert's impressive studio. The son and granddaughter of the well know painter Victor Pasmore, John and Emma enjoyed meeting Robert. Emma was my pottery assistant at the time. Another visitor was the late Potter Ian Godfrey. Robert was working on the suicide project at the time. Ian had recently lost two friends to suicide which Robert was keen to hear about and sympathise with. I think Ian returned a few times to chat with Robert. I never really saw much of Mouse apart from the early 70's when the children were all small and played with my stepson Keir. However I always dropped in to see her in her shop at Yelverton to buy some food in preparation for a walk on the moors. She always greeted me with a hug and a lovely warm smile.

I'm glad I met Robert when I did. He was a very interesting man and as an artist noticed things most people would miss. I'll always remember during our trip to St Ives, as we were walking along, he paused and pointed out the change in colour on a wall as the sun cast a shadow over it.

Shalom.

Chapter Twenty-Six

The Books

I saw Robert a few months ago. He was painting Pattie Avery in his studio. She was sat on a stool steeped in a shrimp coloured silk robe with her blonde hair falling forward. I was so fond of Pattie. It was a beautiful painting with its pearly harmonies. Robert seemed rather serious at first and even seemed to ignore me. I felt a bit awkward especially as he knew I was coming to see him and we had arranged it. Robert's mood was rarely the same. One minute he could be over the moon to see you and the other he could be rather removed at times. You took it in your stride and got used to it. Who knows what was playing on his mind or what stresses he underwent?

As I climbed the stairs in the studio, I noticed a huge glass case of books. I quickly looked at them before entering his studio. They were original works by Emily Dickinson. So, I asked Robert why he had them. I had never heard Robert so fond of a female writer before. Robert was silent and told Pattie he had finished painting her, and then jumped up and gave me a quick kiss on the cheek, (in quite a childish way). Then he showed me an old photograph of Emily Dickinson and began to tell me how her poems were found on her desk after she died. He thought she was very beautiful and had spent many years collecting her first editions and as much memorabilia as he could. He then showed me another photograph of her and said it was thought to be her but no one was sure but her features were similar. We stood there making comparisons for a while, was it or wasn't it her?

Eventually we went downstairs to the library. The library was a space Robert was refurbishing. Gradually, it was developing and becoming more beautiful and reminiscent of the vision he wanted. I remember the door to his library being changed so that it had that lovely little window that everyone always looked through to see if he was there and the lighting changed and then the beautiful red carpet was put in and the shelves. It was such an enjoyment to him and it was a lovely place to meet him and chat, very peaceful and historical like a plush Tudor - style room. It was filled with hundreds of old leather books and his shelves were divided into categories, the occult, metaphysics, philosophy, theology, fascism, art and many of his interests.

At one point I had bound and restored approximately five h8ndred books for Robert. This had been one of the most exhausting but interesting tasks I have ever undertaken. It had all started when my husband, Richard and I returned from New Mexico to live in Devon and later on in Cornwall. I had moved back to England after two years of exploring America. Richard, who I met over there, later

came to visit me and we were married in St Paul's Church of England. Yelverton. Robert gave me away that day. He wasn't well at all and it had taken a huge effort for him to come to the wedding as he was so ill after his heart operation. I remember being quite worried about him. But he still arrived at my wedding.

Richard and I lived in Cornwall just before we were married. Money was very short and we were having difficulties, especially as I had to prove I could support Richard for a year in order to allow him to remain in the country. Richard and I were lucky. We had kindly been offered a beautiful cottage attached to an old manor house just outside Launceston. We were very lucky to have that house. People were very kind to us and helped us out. The countryside and the house we rented were so picturesque with fields and flowers and I even had a lovely studio upstairs. It was here that I carried out the book-bindings for Robert. We were mad to ever leave that beautiful place but life goes on.

I was looking very hard for some work. A few months before, I had written to some book binders in the Devon area asking them if they would take me on as an apprentice. There were many who had heard of Robert. But no one was taking on any apprentices. There was one book in particular that Robert had always pointed out to me in admiration whenever he wanted to spur me on and to get me binding and restoring his books. There was something beautiful about it but Robert and I discussed the possibility of finding another substitute for the cover as we didn't like the idea of using animal skins. This was a time when people thought vegetarians yet alone vegans were rather odd people, yet alone vegans! But Robert and I were aiming to be ethical. While we were searching for a substitute, we began by phoning the wholesalers for scraps of off-cut leather, they were throwing out rather than buy it new. The money that Robert paid me to do the bindings went mainly on gold leaf and quality papers. At least two years of my life was spent in a little room in my flat

binding away to get the books bound perfectly. I knew Robert wanted them a certain way. I knew he was waiting for them.

Eventually, I received a reply form a woman in Cornwall, Launceston who owned a bookshop. Upstairs was where she carried out repairs and binding and she offered me a part time position with her. As soon as I was accepted for this apprenticeship, Robert and I made a deal whereby he would support me through the year by paying me to bind his books but first I would have to learn how to bind my first leather book. I had received a certificate in bookbinding from Brighton Polytechnic and had learnt the basics with some renowned bookbinders at the time. It was very useful because I learnt a great deal about sewing pages and different types of paper and bindings. We all used to exhibit our works in Brighton Pavilions. I enjoyed it immensely but this was the tip of the iceberg in terms of what was awaiting me.

My employer kept me in repairs for quite a long time but leather book binding skills were delicately presented as a future goal. However it was impossible for it to be this long for Robert. He wanted me to start immediately and I really needed to learn leather bookbinding techniques. Robert was obsessed with me doing his bindings. He was also in and out of hospital at this point. I realised just how far his obsession with the books really was and every time I saw him, he would ask me how the binding was coming along and when I could begin on his books. But I had still not reached this point at work and it was difficult to spur dear Felicity on without making myself look too pushy. She was a very nice person.

Richard and I, still had no money. There were no jobs and I really needed to get started. On top of this our car kept breaking down and only just surviving by a hairs breadth each time Richard dropped me off in Launceston at the bookshop. It just took the car to die out one day and we would have no money whatsoever. Ironically it meant

that I had to start binding Robert's books one way or another and then one day it just happened. Somehow, I had bound my first leather book, a book Robert wanted completed. My employer must have noticed my urgency and she started to teach me. They were all so sweet about it when I had completed this first proper full binding and we all had a little celebration downstairs in the bookshop.

Richard and I took the book to Robert while he was in hospital. His face lit up with glee when he saw it. He was sitting in his room at the hospital surrounded by canvases and still wearing his smock in bed. He was pleased with the book although I think finding it quite amusing at the same time. After that he seemed to get better and handed me yet another book to bind. This went on for a long time, for over a year. At the end I had bound approximately five hundred books for him, something he always mischievously laughed about. Sometimes Robert would give me ten books and want them completed within a week. Goodness knows how I managed to do this but I did. I found myself intoxicated with the thought of completing them and making them beautiful. They were very challenging books and demanded a great deal of attention. Robert was so particular about what he wanted, particularly the labels which I embossed with real gold leaf. And they weren't just short labels. Most were in Latin and demanded unusual punctuation. It was the most exhausting procedure and burnt up our electric quickly where I would heat up the embossing tools on the stove.

I began to improve in my technique. The books became more sleek and sharper. Robert liked to keep the most perfect ones on display. One of his favourite books that I repaired was written by the magician John Dee. His face always lit up when he handled this book. I had to completely transfer the original leather binding which had crumbled onto a new leather cover. It was difficult. It became a tradition. Once a week I would go to the Barbican to deliver Robert his books. Robert would be sitting in Joe Prete's Cafe. There would

be a silence once he saw the bag I was carrying. Slowly the books would be unwrapped in front of him. It was like Christmas day every week.

I learnt so much. The ribs on the spine were beginning to look so refined and beautiful. The gold leaf was becoming crisp and clear. I was paring the leather finely. The endpapers were glued on with anti-chemical glues so to reduce mould and deterioration. Some of the books I had re-sewn completely so that the cords were attached to the board themselves and therefore became part of the ribs on the spine. Everything was done according to original bookbinding techniques. I sewed the headbands on with coloured cords of Robert's choice. We really went for it. The whole process from the colour of binding to the type of gold leaf to the endpapers and boards was part of our discussion and an important ritual to deciding the final aesthetic outcome.

Robert began to place them proudly in his library. Quite often I would spot one of my new bindings on the shelf until the shelves began to fill out. It was such fun and we enjoyed the gradual transformation of the bookshelves. Gradually you would see a whole line of black leather bindings with crimson labels and then further books were added.

At the end of the year Richard was legally allowed to claim benefits or work. I had at last proved that I could support him which was something you have to do when you marry a person from the States. It had exhausted me.

Eventually, I moved away from Cornwall and Richard and I travelled further north. My bookbinding era with Robert had come to a sudden and in many ways a sad end. I left Plymouth and I was unaware at the time of how sick Robert actually was. Looking back, if I had known, I would have stayed but he kept these things quiet.

He didn't like talking about his illness. I moved away with Richard and started painting and exhibiting my work. I became involved in many art and poetry projects over the years I will never forget those days and mine and Robert's happiness with the books.

Years later, a friend told me she had been visited by Robert's spirit and that he wanted her to pass me a message. I thought this was all very strange but my friend said that apparently Robert wanted me to become aware of a book I didn't realise was in my possession. I looked everywhere but couldn't find anything unusual. I moved many times since Cornwall and I never noticed this book that she had mentioned. And then something strange happened. Years later, in my current house that I now have in Liverpool, I was one afternoon sorting out some papers on a shelf when all of a sudden with a rather humorous thud and shuffle, a very slim green book fell out in front of me. I was rather surprised and picked it up, looked inside and there were many notes and diagrams Robert and I had made about the books all those years ago, stating what needed to be done and giving me directions on what he wanted with the books with some of their titles and bindings. It was a haunting moment. I turned the pages carefully as it took me back in time. Discovering this book was very useful because it brought the past right back to my present and there was a list of some of the books I bound and restored for Robert with all the necessary requirements for their restoration.

Family Tree

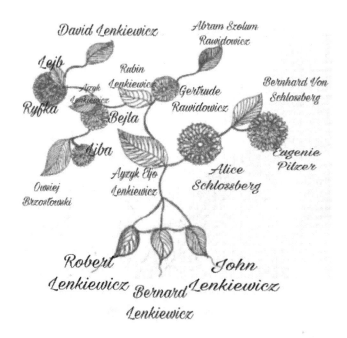

Many years ago, I sold one of my oil paintings to a man, Lars Menk, living in Berlin. It turned out that he was a Genealogist and had published a book called *A Dictionary of German-Jewish Surnames*. It was very interesting to talk to him as he was extremely helpful and went out of his way to find out more about my family heritage. We corresponded for a while and he very kindly worked out my father's family tree.

Dear Alice:

Today your picture arrived, it's wonderful! Thanks a million times! But there's more good news to report...
We've found your SCHLOSSBERG family!
Thursday, I sent an e-mail to the Jewish museum at Frankfurt am Main, asking whether they knew an artist named Bernhard SCHLOSSBERG and whether Oscar, Irene, Rudolph, Carl, and - last not least - Alice SCHLOSSBERG belonged to one and the same family. Today I received the response, and it was much more than I had hoped for.
The archivist Michael Lenarz confirmed that all were children of Bernhard Schlossberg!
The Ancestors of Robert LENKIEWICZ
Genealogical numbering system
The Ancestors of Robert LENKIEWICZ

1st Generation
1. Robert (Reuben) Oscar LENKIEWICZ
b. 31 Dec 1941 in Hendon, Marylebone, London; d. 05 Aug 2002 in Plymouth, Devon
[NOTE: You father was obviously named after his grandfather, Re'uven
'Rubin' LENKIEWICZ, according to the traditional Ashkenazi naming pattern.

2nd Generation
2. Ayzyk Eljo 'Isaac' LENKIEWICZ
b. 22 Jun 1898 in Grajewo, Lomza Gubernia, Poland; d. 1958 in Hampstead,
London (vol. 5c, p. 672)
Russian nationality until 1951
Jan 1941 horse dealer at 105 Wentworth Rd., Golders Green, London NW 11; Dec

1941 jeweller's mechanic at 24 Brookside Road, Hendon, Golders Green, London
NW 11; 1951 boarding-housekeeper at 85-87, Fordwych Road, London, N.W.2; 26
Jan 1951 naturalized
'Ayzyk Eljo' corresponds to the Hebrew 'Yitzhak El'yahu', or in English
Isaac Eliah.
m. 23 Jan 1941 in Hendon, Middlesex (vol. 3a, p. 1472):
3. Alice SCHLOSSBERG
b. 12 Jun 1900 in? Frankfurt am Main; d. 1977 in Hampstead, London vol.
12, p. 1979
Jan 1941 domestic servant in London NW 11; 26 Jan 1951 naturalized
Children - Robert Oscar LENKIEWICZ; b. 31 Dec 1941 in Hendon, London; d. 05 Aug 2002
in Plymouth
Bernard LENKIEWICZ, b. 31 Dec 1941 in Hendon, London
John Elliot LENKIEWICZ, b. 1944 in Bishops Stortford
? John Carl LENKIEWICZ, b. 23 May 1949 in ...

3rd Generation
4. Rubin (Robert) LENKIEWICZ
b. abt. 1870 in ? Grajewo; d. 1936 in Dresden, Germany
horse dealer
'Rubin' is a form of the Hebrew 'Re'uven'.
m.
5. Gertrude RAWIDOWICZ
b. abt. 1875 in ? Grajewo, Lomza Gubernia, Poland
1945 in 'Alcatraz' ? Argentina
Children: Ayzyk Elio LENKIEWICZ, 1898; Perla Fejga LENKIEWICZ, 1898
6. Bernhard SCHLOSSBERG

for the family SCHLOSSBERG see below

4th Generation
8. Ajzyk LENKIEWICZ
b. ca. 1834 in Szczuczyn; 1855 in Szczuczyn
m. 1855 in Grajewo:
9. Bejla Estera BRZOSTOWSKA
b. ca. 1832
After him your grandfather Ayzyk was named
10 ? Abram Szolim RAWIDOWICZ; b. abt. 1835 in ? Rajgrod,
Lomza gubernia, Poland
Children:
Chaim Icko RAWIDOWICZ; m. 1884 in Grajewo: Chana
REMBELINKER; Children (in Grajewo Reijza, b. 1885; Jetla, b.
1887; Jankiel Mortchaj, b. 1894
Szimen, b. 1897; Szapsaj, b. 1899
Fajwel Moszek RAWIDOWICZ; m. 1889 in Szczuczyn, Lomza
gubernia: Frejda
daughter of Abram Izarel KACPOWSKI; Children in Grajewo - Elia
Wolf, b.
1891 - Szimen / Szimko, b. 1899
Chana Liba RAWIDOWICZ; m. 1890 in Grajewo: Mejer Zelik
ROTMAN

5th Generation
16. Lejb LENKIEWICZ
b. abt. 1810 in ...
'Lejb' is the Polish-Yiddish form for the the old Jewish 'Loeb', from
the
Middle High German, meaning 'lion', attributed to the Hebrew
'Yehudah'
17. Ryfka ...
in English: Rebecca
18. Owsiej BRZOSTOWSKI

189

b. abt. 1805 in ...
'Owsiej' is the Polish transcription of the Yiddish 'Ovshey', a
Yiddish
form of the Hebrew 'Yehoshua'
19. Liba ...
The Yiddish female given name 'Liba' comes from the
German'Liebe', meaning 'love'.

6th Generation
32. Dawid LENKIEWICZ
b. abt. 1780 in ...
34. Chaim ...
'Chaim' is another spelling of the Hebrew 'Hayyim', meaning 'life'.
36. Lejzor BRZOSTOWSKI
'Lejzor' is a Polish-Yiddish short form of the Hebrew 'El'azar'.
The family of Bernhard von SCHLOSSBERG
Bernhard SCHLOSSBERG
b. 26 Nov 1851 in 'Podbresch', Russia; d. 29 Sep 1907 in ? Frankfurt
am Main - Jewish, later 'freireligiös' ('free religious')
He emigrated (or fled?) from Russia to Austrian Poland, where he
became Austrian citizen in Chrzanów (between Katowice and
Kraków, Poland); 1884 in Krefeld (North Rhine), 1887 in
Wiesbaden (Hesse), since 24 Aug 1887 in Frankfurt am Main
m. 04 Apr 1884 in Krefeld:
Eugenie PILZER; b. 02 Aug 1866 in Chrzanów; d. 30 Oct 1918 in
Frankfurt am Main
1913 operating as a painter? with fixed office hours in Frankfurt
NOTES:
'Podbresch' most likely is Paberžė in Lithuania, which in Polish is
called Podbrzezie, in Yiddish Podberezhe, in Russian Podberez'e,
located 18 miles N of Vilnius / Vilna.
In the 19th century, Chrzanow was located in the westernmost part
of Galicia in the Austrian

Empire, less than 20 km East of the border to German Silesia (Schlesien).

As Bernhard's profession is specified "painter" or "portrait painter" In Frankfurt's address books, he operates as "artist" or "portrait painter".

In the address books Bernhard calls himself "Bernhard von Schloss Berg," later "Bernhard von Schlossberg." The 1908 Address Book printing at about the time of his death) refers to him as the owner of a company "v. Schlossberg & Co, portrait painting." To that name variant there's a note on the residents' registration card, "Schlossberg, born Russian, later naturalized in Austria, district commission of Chrzanow. In the past he called himself 'von Schlossberg'; but without being able to prove that he legitimately bears that name, he was prohibited to continue bearing that name, and was permitted to call himself just 'Schlossberg'." The address books, however, show that he didn't abide to that decree, but called himself "von Schlossberg" until his death.

Born in 1845, King Ludwig II. was only slightly older than Bernhard. Ludwig committed suicide - or, as others believe, was murdered - in 1886. We don't know where exactly Bernhard lived and what he did prior to 1884, when he got married in North Germany. The frequent moves of the family, and other circumstances that are mentioned on the registration cards, indicate that his living conditions were rather precarious. This feeds doubts about the alleged relationship to King Ludwig II.

Generally said, 'von' simply means 'from / of (somewhere)'. When in Germany people began to add surnames to their given names, they were often called by the place where they had come from, which could have been the name of a town or village or castle, with the 'von' added. Or 'von Schlossberg', which means 'from (the) castle mountain' - which, however, somehow suggests a noble family.

Children:

Victoria SCHLOSSBERG; b. 16 Oct 1884 in Bielefeld (or Krefeld?); later she lived in the Heilanstalt (insane asylum)

Weilmuenster [The asylum at Weilmuenster was one of the places where the Nazis interned mentally ill persons, which either died there or were later murdered at Hadamar.] no further information
Oskar (Oscar) SCHLOSSBERG; b. 21 [or 31?] Oct 1887 in Frankfurt am Main
01 Aug 1910 moved from Frankfurt to Strassburg / Strasbourg in the Alsace; 1936/37 merchant at Mannheim; 14 Mar 1937 arrived at New York from Hamburg an the 'President Roosevelt'; 1942 in New York, NY, 601 W 151st St.
m.
Ella Esther SOMMER; b. 02 Mar 1895 in Bad Homburg; d. 25 Nov 1991 in ... ; daughter of Siegmund SOMMER, 1936 in Mannheim; 13 Dec 1936 arrived with children at New York from Le Havre on the 'Britannic' (3rd class), moving to her brother, Eugene SOMMER, in the Bronx or Wilmington, DEL; 1944 in the Bronx, 2 E 167st St., 20 Dec 1944 naturalized (U.S. District Court at NYC, southern district)
Children:
Ruth Karoline SCHLOSSBERG; b. 06 Nov 1916 in Mannheim; 1944 unmarried, in the Bronx, NY, 1018 Summit Ave.; 01 Feb 1944 naturalized (U.S. District Court at NYC, southern district)
Edith Eugenia SCHLOSSBERG; b. ca. 1919 in Mannheim
Irma Dora 'Irene' SCHLOSSBERG; b. 27 Feb 1889 in Frankfurt a. Main; d. 194.. in Auschwitz; lived at Frankfurt a. Main; 1913-14 in Berlin, then back to Frankfurt; 1942 deported from Frankfurt to an unknown place (there are restitution files!) Child (illegitimate):
Erika SCHLOSSBERG; b. 30 Nov 1913 in Berlin; 1939 in Frankfurt am Main; ca. 1939 escaped to England
Rudolf / Rudolph SCHLOSSBERG; b. 09 Jul [07 Sep?] 1890 in Frankfurt am Main; painter / artist, photographer, 1920-38 merchant (preserves, chocolate) in Frankfurt am Main, 1937 at Battonstr. 34; 1953 in Brooklyn, NY, 2865 Brighton 3rd St. bk.; 30 Jun 1953 naturalized (U.S. District Court at Brooklyn)
m. 17 Jul 1919 in Frankfurt am Main:

Ida Wilhelmine Lisette SCHUETZE; b. 08 Mar 1892 in
Wattmannshagen, Kr. Guestrow, Mecklenburg-Vorpommern;
Jewish [coverted to Judaism]
Lucie SCHLOSSBERG; b. 03 Jun / d. 18 Jul 1892 in Frankfurt am
Main
Karl (Carl) 'Charles' SCHLOSSBERG; b. 20 Dec 1894 in Frankfurt
am Main; until 1912 in Frankfurt am Main; since 1914 in the USA;
1920 servant in a boarding house in Brooklyn, NY, 55 Pierrepont;
1937 at New York, NY, 547 South. Blvd.; 1942/44 at 301 W 57th
St., NYC; 20 Jan 1944 naturalized (U.S. District Court at NYC,
southern district)
Alice SCHLOSSBERG; b. 12 Jun 1900 in Frankfurt am Main; last
mentioned in a list of foreigners from 1934 as living in Frankfurt
(stateless, office clerk). A sister of Irene Schlossberg lived in the
UK, which actually can only be Alice. Most of the information
about the time of the family SCHLOSSBERG at Frankfurt am Main
came from the archivist Michael Lenarz:
Michael Lenarz, Stadt Frankfurt am Main, Der Magistrat, Jüdisches
Museum,Michael Lenarz,Untermainkai 14/15, 60311 Frankfurt am
Main,Tel.: 069-212-38546, Fax: 069-212-
30705mailto:michael.lenarz@stadt-
frankfurt.dewww.juedischesmuseum.de

Drawings of Mouse

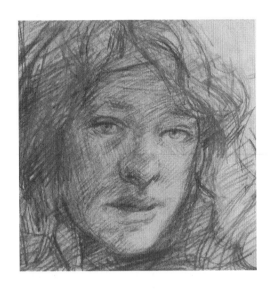

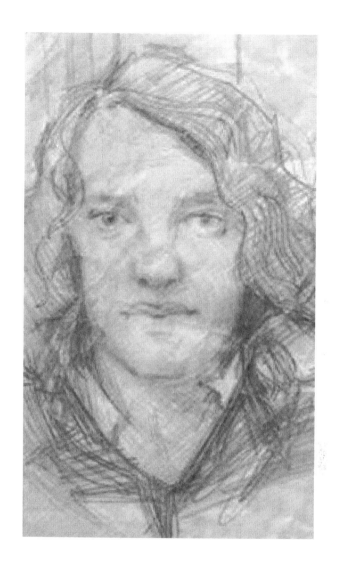

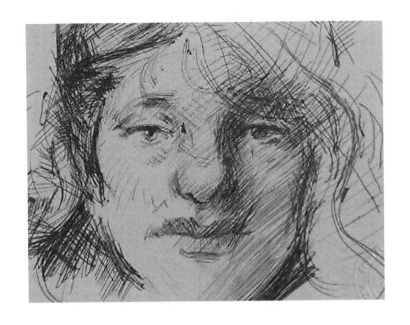

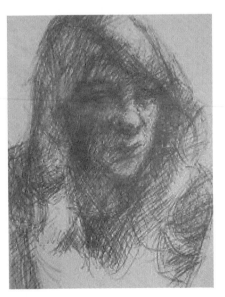

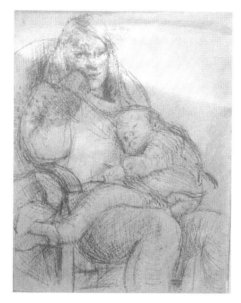

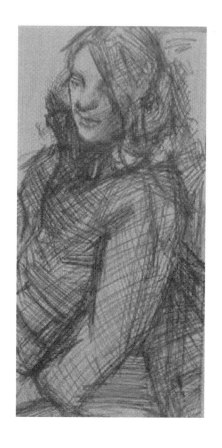

Paintings of Alex Donoghue

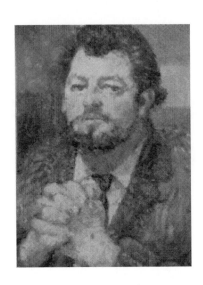

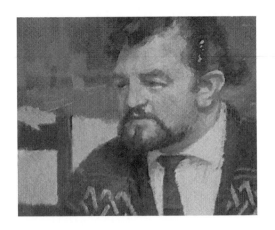

Drawing of me by Robert

Me, Mouse and Becky in our flat in Stoke, Plymouth

Mouse at our flat in Stoke, Plymouth

Photos of us at Trevauden Cottage by Tarun Bedi

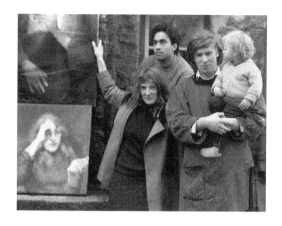

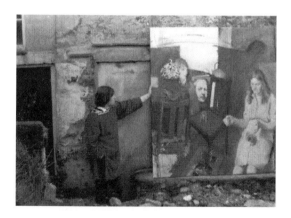

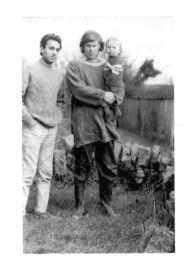

Robert and Tarun

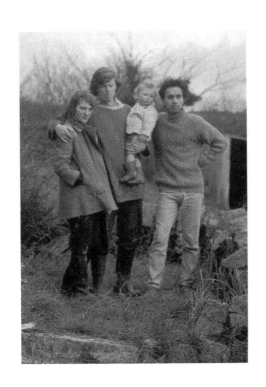

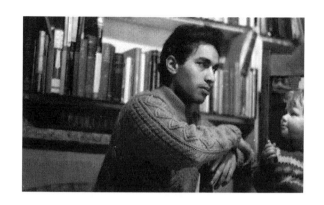

Robert, Ma and Mouse

Westminster Photos by Derek Winkworth

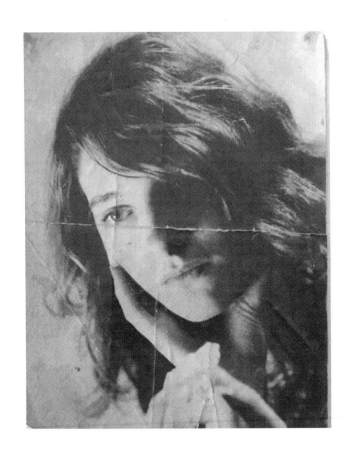

It is now the year 2019 and I reflect on the past. For a long time, I have been immersed in completing this memoir. It wasn't easy facing some of these memories as so much time has passed and life has changed so much since those days. There are fond memories but there is no escaping the fact that some of these past experiences were challenging. There are certain things that I notice such as our frequent moving of home. Up until I was eleven years of age, we had moved between twelve homes and possibly more for very short spells.

We as a family had difficulties in finding suitable accommodation and affording rent. I do remember so many years of hardship in terms of money and Mouse worrying about food and bills and us all getting by. Even though we always managed to get somewhere to stay, there was no place we could actually settle and call a proper home for many years.

It was only when we moved to Lower Compton Road in Mannamead that we finally settled in a little council house, where we were happy for many years. There were also those who had no home at all, the elderly, those with dementia and mental health problems, those with alcohol and drug addictions. They would have been grateful for any help they were offered. Throughout this time, Robert and Mouse both still managed to give out to others and that was an honourable trait. It can't have been easy.

It seems so strange that seventeen years have now passed since Robert and I last spoke. I often wonder what we would be talking about now if he was here. In many ways it was always taken for granted that Robert was there. It seemed normal at the time to see him on The Barbican in Plymouth, discuss antiquarian books and art, to eat our Christmas meal with the homeless down at Plymouth bus station and pose for paintings and experience all his

eccentricities. As much as they caused alarm and excitement they were at the time, considered part of our lives and quite normal. But looking back and seeing how much has changed, even though I always admired my father, I see even more just what an incredible man he was.

Robert introduced me to an enigmatic and colourful world. It is because of Robert's influence and tuition that I paint today. He instilled me with so much inspiration. One thing I admired about Robert was he never pandered to establishment rules or used his education to advance his status in the art world. Neither did he take the 'back door' route into the system. Robert's life was genuine hard work and in many ways a struggle but he carried on regardless, stood his ground and led the artist life he wanted. My mother, Mouse has always worked hard and in her creative and spiritual self she is a survivor and very much loved and I love her dearly.

I am happy I have written this memoir. It feels as though I have completed something that needed to be told, that was hidden away for a very long time. I am overjoyed that the charity 'Shelter' agreed to support this book on behalf of Robert's work helping the homeless. It makes me happy to know that each time this is read, proceeds will go to a cause that Robert supported and put much of his time and effort into, that of helping the homeless. There is so much more I could have written in this book. I will probably remember different things that I could have mentioned at a later time. Perhaps that's something for the future. For now, this is all I needed to say.

I will always remember and admire my dear, talented father Robert. I hope this journey into my past and that of my parents and friends has offered you a glimpse into a world that although has now vanished, still remains a significant part of our hearts and souls.

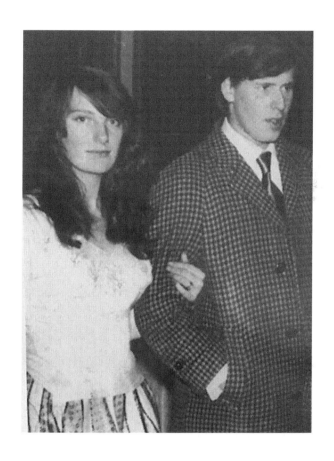

A Selection of books, I restored and bound for Robert.

1:
Physica Misteriosa
Magica
MSS
Variis Authoribus
1791

2:
IMMANUEL KANT
His Life and Doctrine
F. Paulsen
1902

3:
Kant's Theory of Mental Activity
R.P. Wolfe
1913

4:
Satan's Invisible World Discovered.
George Sinclair
1815

5:
Les confessions de S. Augustin
D'ARNAULD D'ANDILLY.
1676

6:
Trithemiius
Steganographia
MSS

7.
48:

De Secretis Mulierum
Albertus Magnus

8:
De Re Medica
Serenos Sammonicus
1540

9:
The History of Philosophy
Thomas Stanley
1687

10:
The Lancashire Witches, and Tegre O Divelly The Irish- Priest.
A comedy acted at the Duke's Theatre.
Thomas Shadwell
First edition: 1782

11:
The Doctrine of Virtue
Emanuel Kant
1963

12:
Occult Science Investigated
Thomas White
1811

13:
Astral Natural Prophesy
E.V. Williams
Missing title paper
No date - 1860?

14:
Critique of Pure Reason
Kant
1855

15:
Legends of Florence
C. G. Leland

16:
The Philosophy of Kant
F. Hall- Sta
1877

17:
The Life of Voltaire
With interesting Particulars
Respecting his Death
Frank. Hall
1821

18:
The Oedipus Romanus
G. Townsend
1819

19:
Saunders on Palmistry
1663

20:
Critique of Pure Reason
I. Kant
1900

21:
Essay on the Eleusinian Mysteries
M. Ouvaroff
1817

22:
KANT
W. Wallace

1899

23:
A CRITICAL ACCOUNT OF THE
PHILOSOPHY of KANT
Edward Caird M. A
1877

24:
Development of Kantian thought
H. J. De Vleeschauwer
1962

25:
NINEVEH and IT'S REMAINS
Austen Henry Layard
1849

26:
Development of Kantian Thought
H. De Vleeschauwer
1962

27:
The commentaries of Proclus on the Timaeus of Plato by Thomas
Taylor
1988

28:
Lancashire Witches
T. Shadwell

29:
LISA
Mathew Lipman
1983

30:
MARK

Mathew Lipman
1980

31:
Philosophical Enquiry
M. Lipman
A. M. Sharp
F. Oscanyan
1979

32:
Astrolo- Physical Compendium
Richard Ball
1794

33:
Miscellanies
Apparitions
Magick
Etc
Tom Audrey
1784

34:
Lives of the Necromancers
William Godwin
1834

35:
Practical Astrology
Middleton

36:
Death
Judgement
Heaven
Hell
William Bates
1691

37:
Giordano
Bruno
L. McIntyre
1903

38:
Looking for meaning
Mathew Lipman- Ann. M Sharp
1982

39:
Social Inquiry
Mathew Lipman -
Ann. M Sharp
1980

40:
Ethical Inquiry
Mathew Lipman -
Ann. M. Sharp
1985

41:
Raphael's Witch
1835

42:
Kant's solution for verification
In Metaphysics
D.P Dryer
1966

43:
Imblichus - On the Mysteries
Edited by Stephen Roman
1989

44:
The Astro Philosopher
Simmonite
1844

45:
LIVRE DE LA VIGNE
NOSTRE SEIGNEUR
Bodleian
MS. DOUCE 134
Facsimile

46:
The Works of the Most, High and Mightie Prince James King of
Great
Britain - Containing DAEMONOLIGIE
IN THREE BOOKS
1660
MDCXVI

47:
Anatomy
Andrew Fyfe
1812

48:
John Dee and Tudor Geography
E.G.R Taylor
1930
Facsimile

49:
Ethical Enquiry
Mathew Lipman -
Ann M. Sharp

50:
A. J. Penny
1912

51:
De Occulta Philosophia
MSS
Cornelius Agrippa

52:
The World to Come (Great Awakening Writings (1725-1760))
Isaac Watts

53:
John Dee's
Actions with Spirits

54:
The Spirit of Partridge
1825

55:
Oedipus Judaicus by William Drummond

56:
Oedipus Rominus
George Townsend

57:
Astral of natural Prophesy
E. V. Williams
1860?

58:
Cap T Rudd - John Dee Euclid's Elements of Geometry.

59:
An Inquiry into the human mind
Thomas Reid

60:
Occult Science Investigated- Thomas White

Chronology

1961 – Mouse at Bury Place, Russel Chambers, Bloomsbury.

1962 – Shared flat with Rita from St Martins and Marion at Queensway then Belsize Park.

1962 – Moved in with Robert to 4, Eton Avenue.

1963 – Went to horrible flat at Chalk Farm.

1963 – Steeless Road off Haverstock Hill.

Pregnant with Alice and through sickness moved back to Polmartin in Cornwall for 3 months.

We got married and Robert got a job for 2 terms in Drakewalls school and we lived in a flat at Drakewall's House.

1964 – Gave birth to Alice and went back to Polmartin for 2 weeks and then to Hotel Shemtov for 3 or 4 months.

1965 – went to Fitzroy road – adjacent to Primrose Hill.

1965 – 53 Eton Avenue

1966- Trevorden Cottage, given free living for one year as long as we decorated the place. We didn't.

1966 – Moved to 24, Clifton street, Plymouth. Gave birth to Wolfe.

1967 – Moved to 7, Rectory road. Robert and I parted.

1968 – Turnchapel

1968 – 1, Keppel Terrace, gave birth to Becky.

1969 – Clifton Street – Terry Goldstones House.

1970 – 2, Warfelton Terrace, Saltash.

1971 – Wolsden St.

1972 – Robert's place, Priory Road for four months.

1972 – 6, Havelock Terrace.

1975 – 11, Lower Compton Road (Our first and last council property)

In aid of

Shelter

Printed in Great Britain
by Amazon